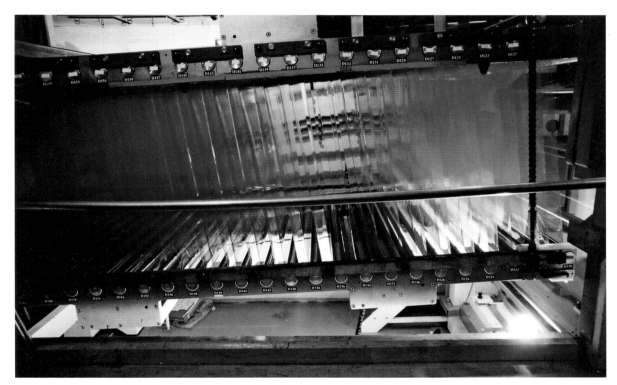

PREVIOUS
HUGO BOSS
PRIZE
RECIPIENTS

2006
ABOVE:
TACITA DEAN
Kodak, 2006. 16mm color
and black-and-white
film with optical sound,
44 minutes. Solomon R.
Guggenheim Museum,
New York. Purchased with
funds contributed by the
International Director's
Council and Executive
Committee Members
2007.129

2004
BELOW:
RIRKRIT TIRAVANIJA
*Untitled 2002 (he
promised)*, 2002.
Chrome and stainless
steel, approximately
3 x 12 x 6 m. Solomon R.
Guggenheim Museum,
New York. Purchased with
funds contributed by the
International Director's
Council and Executive
Committee Members.
2004.124. Installation view,
Secession, Vienna, 2002

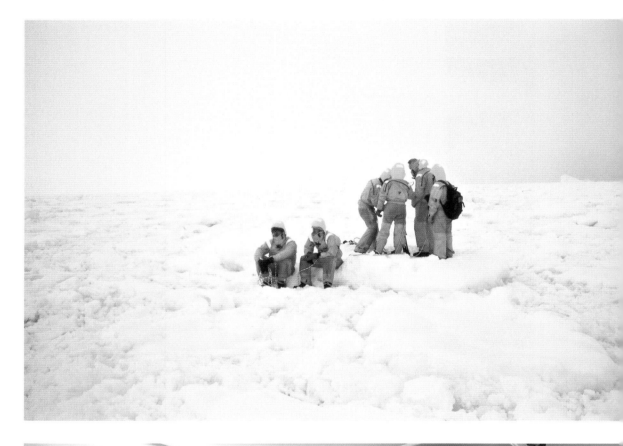

2002
ABOVE:
PIERRE HUYGHE
A Journey That Wasn't,
2005. Super 16mm film
and high-definition video
transferred to high-
definition video with
color and sound;
21 minutes, 41 seconds

2000
BELOW:
MARJETICA POTRČ
*New Orleans: Shotgun
House with Rainwater-
Harvesting Tank,* 2008.
Building materials,
energy, communications
and water-supply
infrastructure,
dimensions vary with
installation. Installation
view, Max Protetch
Gallery, New York, 2008

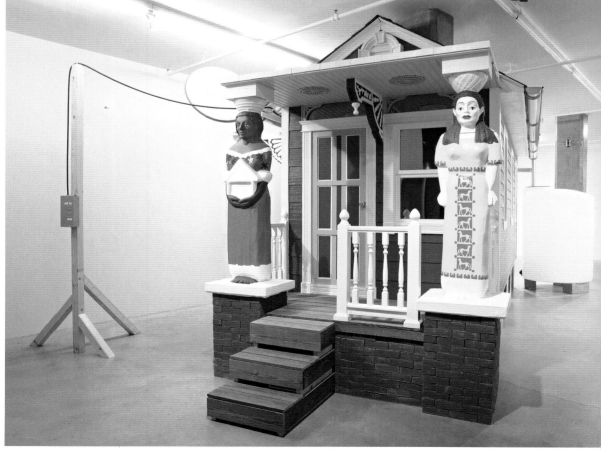

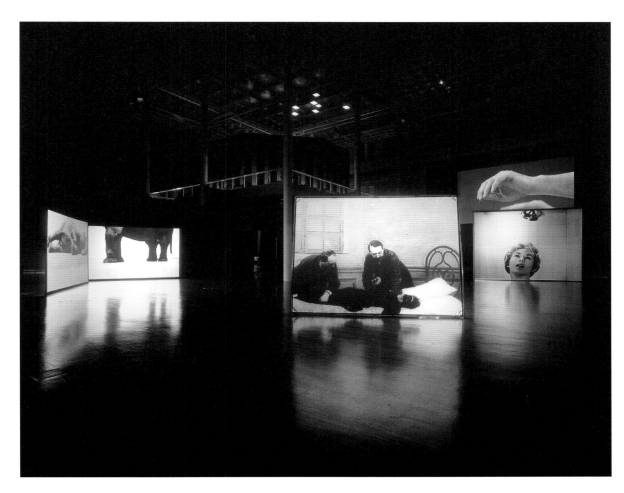

1998
ABOVE:
DOUGLAS GORDON
Douglas Gordon: Between Darkness and Light. Works 1989–2007, showing from left to right: *Play Dead: Real Time* (2003), *Hysterical* (1994–95), *Feature Film* (1999), *24 Hour Psycho* (1993). Installation view, Kunstmuseum Wolfsburg, April 20–August 12, 2007

1996
BELOW:
MATTHEW BARNEY
DRAWING RESTRAINT 15, 2007. Documentary photograph

ACKNOWLEDGMENTS THOMAS KRENS
DIRECTOR OF
THE SOLOMON R. GUGGENHEIM FOUNDATION

With the selection of the first group of finalists and bestowal of the inaugural award to Matthew Barney in 1996, the biennial Hugo Boss Prize established itself as an arbiter for significant developments in contemporary art. The international group of finalists, which included Laurie Anderson, Janine Antoni, Cai Guo-Qiang, Stan Douglas, and Yasumasa Morimura, and each short list thereafter has adhered to the pledge to recognize talent throughout the world. Since its founding, when there were few other contemporary art prizes without specific geographic, media, or exhibition parameters (the Kurt Schwitters and Wexner Prizes are two examples), the number of significant art prizes has risen noticeably with the announcement of a new award, usually limited to a specific nationality or practice, seemingly occurring each year (recent additions include the Düsseldorf Kunstpreis, established 2006, and the Zurich and Joan Miró Prizes, both established 2007). The proliferation provides worthy recognition and support to deserving artists, and we are pleased that The Hugo Boss Prize remains one of the most prestigious distinctions.

The six finalists for the 2008 Hugo Boss Prize—Christoph Büchel, Patty Chang, Sam Durant, Emily Jacir, Joachim Koester, and Roman Signer—reflect some of today's most innovative practices, which are discussed and illustrated in the pages of this catalogue, and address a variety of compelling media and social and aesthetic concerns. The publication, to which each artist has been invited to contribute a seven-page project that is accompanied by a commissioned essay, celebrates the work of this year's short list of exceptional talents. The winner will receive a grant of $100,000 and his or her work will be presented in a solo exhibition at the Guggenheim Museum.

The successful realization of The Hugo Boss Prize is the result of a fourteen-year collaboration between institutions and individuals to whom we are deeply indebted. HUGO BOSS's commitment to the visual arts and innovative ideas about cultural sponsorship were the catalyst for the foundation of the prize, and we are grateful for their continued patronage of this as well as numerous other programs at the Guggenheim Museum. Sincere thanks must be expressed to Dr. Hjördis Kettenbach, Head of Cultural Affairs, HUGO BOSS AG, who has insured that all organizational details of the prize have been handled with meticulous care. We are also indebted to Philipp Wolff, Director of Worldwide Communication, for his enthusiastic support. They have been ably assisted by a dedicated team, including Markus Aller and Ildiko Sahin.

The group of finalists for the 2008 Hugo Boss Prize reflects the unique perspectives of the jury members who faced the formidable challenge of selecting the finalists and, ultimately, the recipient of the prize. We were most fortunate to have been able to rely on the expertise and dedication of Russell Ferguson, Chair, Department of

Art, University of California, Los Angeles; Maria Lind, Director of Graduate Program, Center for Curatorial Studies, Bard College, Annandale-on-Hudson, New York; Sandhini Poddar, Assistant Curator of Asian Art, Solomon R. Guggenheim Museum; Nancy Spector, Chief Curator, Solomon R. Guggenheim Museum; and Marc-Olivier Wahler, Director, Palais de Tokyo, Paris. We are grateful for the informed consideration they brought to the nomination and selection process.

At the Guggenheim, numerous individuals have contributed to the facilitation of The Hugo Boss Prize and its accompanying publication. Joan Young, Associate Curator of Contemporary Art and Manager of Curatorial Affairs, has ably overseen all aspects of this project. Nancy Spector, Chief Curator, provided essential guidance. We would also like to express our gratitude to John Wielk, Executive Director of Corporate and Institutional Development; Stacy Dieter, Director of Corporate Development; and Lisa Brown, Manager of Corporate Sponsorship, for their vital roles as liaisons between the museum and HUGO BOSS. Our appreciation also goes to Alyson Carey, Education/Public Programs Intern; Betsy Ennis, Director of Media and Public Affairs; Sara Geelan, Associate General Counsel; Eleanor R. Goldhar, Deputy Director for External Affairs; Paul Kuranko, Electronic Art and Exhibition Specialist; Anna Lavatelli, Theater Technician; Michael Lavin, Director of Theater and Media Services; Jessica Ludwig, Director of Exhibition Planning and Implementation, New York; Rachel Selekman, Interim Program Manager, Public Programs; Dana Wallach, Assistant General Counsel; and Christina Yang, Associate Director of Education, Public Programs, for their contributions. Curatorial interns Emelia Meckstroth and Cora von Pape provided invaluable research assistance and administrative support throughout the many phases of the 2008 prize.

This publication is the result of the labors of many talented individuals. We would like to acknowledge authors Dr. T.J. Demos, Liza Johnson, Shanna Ketchum-Heap of Birds, Lars Bang Larsen, and Dr. Gerhard Mack, whose essays provide valuable insights on the work of the finalists. Ethan Trask and Joshua Liberson of Helicopter are responsible for the catalogue's inventive design. We are also indebted to those who have produced this catalogue: Elizabeth Levy, Director of Publications; Elizabeth Franzen, Associate Director of Publications, Editorial; Stephen Hoban, Managing Editor; Helena Winston, Associate Editor; Melissa Secondino, Associate Director of Publications, Production; Minjee Cho, Associate Production Manager; editors Catherine Bindman and Jean Dykstra; and Russell Stockman for his translation services. We would also like to thank Mike Bellon, Dr. Holger Broeker of Kunstmuseum Wolfsburg, Sicco Diemer, Sophie Dufour, Glorimarta Linares, Una McGeough, and Chloé Zaug for their generous assistance in securing images for the publication. Mario Testino deserves sincere thanks for permitting the reproduction of his photography for HUGO BOSS's 2008 campaign as well.

We are especially appreciative of the representatives and studios of the artists for their help throughout the preparatory stages of this project and the accompanying publication: Theodore Bonin and Oliver Newton, Alexander and Bonin, New York; Steve Henry, Paula Cooper Gallery, New York; Cal Crawford; Candice Lin, Sam Durant studio; Carol Greene, Greene Naftali, New York; Cornelia Providoli and Karin Seinsoth, Hauser and Wirth, Zurich; Ellen Langan, Maccarone, New York; Barbara Signer, Roman Signer studio; and Peter Zimmermann.

And finally, we offer our deepest respect and gratitude to the artists for the stimulating inspiration they continuously provide.

INTRODUCTION JOAN YOUNG
ASSOCIATE CURATOR OF CONTEMPORARY ART
AND MANAGER OF CURATORIAL AFFAIRS

Every two years since 1996 a jury of curators and museum directors from around the world has gathered at the Guggenheim Museum in New York to share thoughts on the most significant trends in contemporary art. The jurors are invited on the basis of the unique perspectives they can provide on artists in their own communities as well as in the international realm. While, inevitably, no single jury can offer an entirely comprehensive view of artistic activity around the globe, its shortlist of finalists for The Hugo Boss Prize certainly reflects some of the most dynamic artistic practices of the moment. There are no restrictions in terms of media, age, or gender. Artists may have had careers of as few as ten or as many as thirty years, but in order for them to be considered for the prize the impact of their aesthetic and conceptual approaches should have begun to reverberate in the art world. While the finalists are not selected for a commonality in their individual practices, the artists on this year's shortlist are all engaged in contesting the structures established by social, economic, political, historic, and cultural institutions.

Swiss artist Christoph Büchel is perhaps best known for his elaborate large-scale installations that blur the distinctions between fiction and reality, art and everyday life, challenging the viewer's perceptions of the artist's often unnerving microcosms of material remains. In *Close Quarters* (2004), for example, Büchel transformed the main

gallery of the Kunstverein Freiburg into a school gymnasium adapted to hold asylum seekers. Visitors roamed through the cell-like rooms, piecing together a narrative for the fictional history of this space. Throughout his practice, Büchel exposes the political, social, and economic conditions of cultural production, at times even questioning the economic significance of his own participation in an exhibition. For a work titled *Invite Yourself* (2002), Büchel sold his invitation to participate in *Manifesta* 4, the European Biennial of Contemporary Art held that year in Frankfurt am Main, Germany, on eBay to the highest bidder; it was bought by American artist Sal Randolph, who then proffered an open invitation to anyone wishing to take part in free public art projects as part of her own event, *Free Manifesta* (more than 225 artists and groups were ultimately to participate). On the occasion of the publication of The Hugo Boss Prize catalogue this year, Büchel has produced a project that points to the symbolic value the prize confers on the artists' work as well as on the reputations of the museum and the sponsor. In striving to make this mutually beneficial arrangement more transparent, Büchel has traded the pages of the catalogue that would have featured images and a commissioned text on his work to HUGO BOSS for advertising, reprinting pages from the fashion house's catalogue in exchange for 500 shares of the company's stock to illustrate how the publication represents a form of promotion for all the entities involved with the prize.

American artist Patty Chang examines popular female and cultural stereotypes, including the objectification and "exoticization" of women as well as various concepts of beauty, desire, and dignity. Her early photographs and videos document performances in which the artist interacts with various objects, often testing the limits of her own endurance and discomfort as well as those of her audience. In the performance and video *Untitled (Eels)* (2001), for example, the viewer observes Chang squirming and breathing heavily as eels writhe inside her blouse, although it is not clear whether the artist is experiencing torture or ecstasy. This ambivalence persists in her more recent video and photographic projects in which Chang has a less significant role as a performer, focusing instead on the melding of the real and the imaginary in narratives that she situates in specific cultural contexts. In *Shangri-La* (2005) she visits a town in China called Zhongdian, marketed to tourists as the site of the mythical heaven-on-earth described in James Hilton's book *Lost Horizon* (1933), using the natural and artificially constructed landscapes as settings for her interactions with the industries established to promote the newly fabricated identity of the location.

American artist Sam Durant exposes some of the myths surrounding American history. He is particularly interested in the ways in which our understanding of that history has been mediated and distorted by the images of and monuments to certain groups that have been privileged at the expense of others. His multimedia projects have addressed such instances of hypocrisy and inequality as the treatment of Native Americans by the Pilgrims as well as those protested by the civil rights movement of the 1960s. Durant draws associations between the politics, popular music, and art and design of these eras to explore the charged nature of political dissent and the abuse of the essential foundations of freedom upon which America

was founded. *Partially Buried 1960s/70s Utopia Reflected, Dystopia Revealed* (1998), for example, consists of two mirrors covered with dirt in which tape recorders have been buried; here, as he has done in several other works, Durant references Robert Smithson's *Nonsite* sculptures of 1968–69 that incorporated stones or soil from specific locations, as well as that artist's land art work titled *Partially Buried Woodshed* (Kent State University, Kent, Ohio, January 1970). Peaceful proclamations to the crowds at Woodstock emanate from one tape recorder; from the other are heard pleas for order at the Altamont Speedway Free Festival or "Woodstock West," a rock concert organized by the Rolling Stones on December 6, 1969

CHRISTOPH BÜCHEL
Close Quarters, 2004.
Mixed media, dimensions
vary with installation .
Installation view,
Kunstverein Freiburg, 2004.

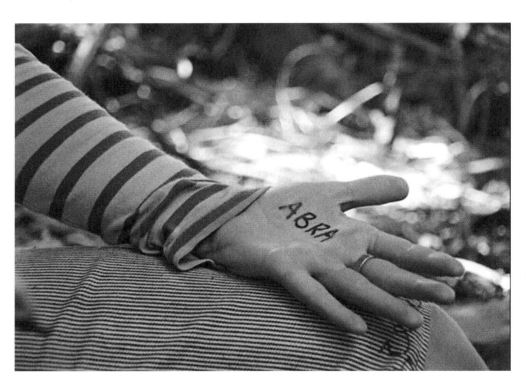

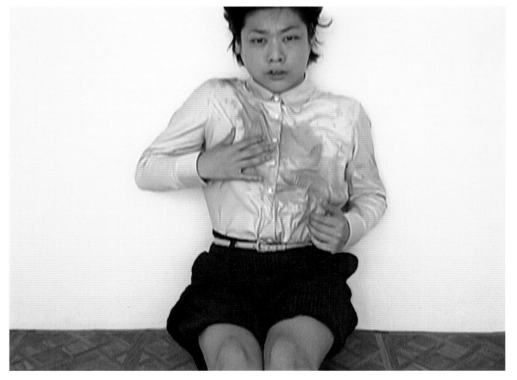

in northern California that was marred by violence and four deaths. Durant sees these two legendary festivals of the sixties as representing the contradiction inherent to the utopian hopes of the decade.

Palestinian artist Emily Jacir's work involves a diverse range of media that often incorporate personal and/or collaborative actions, interweaving individual, national, and transnational histories to address themes of displacement. In *Where We Come From* (2001–03), Jacir highlights the value of the right to unrestricted travel in a project that documents in text and photographs the modest, everyday acts, such as visiting a mother's grave or eating a favorite meal, that she offered to perform in the homeland of Palestinians who were not easily able to travel there. The ongoing multimedia project *Material for a film* (begun in 2005) addresses the life of Wael Zuaiter, the first victim in Europe of a series of assassinations of Palestinians perpetrated by Israeli agents following the deadly kidnapping of Israeli Olympic athletes in 1972 (a crime to which Zuaiter was ultimately never linked). The project is derived from a chapter titled "Material for a film" in Janet Venn-Brown's 1984 book *For a Palestinian: A Memorial to Wael Zuaiter*, and integrates archival documentation, narrative, film, and sound to present a richly layered analysis of Zuaiter's tragic death.

Danish artist Joachim Koester presents his investigations of aspects of history that have faded into obscurity in his photographs, films, and installations. Drawn from a variety of literary, geographic, photographic, and film sources, his archival research often leads him to explore such transgressive figures as the Belgian poet and painter Henri Michaux (1899–1984). In a project titled *My Frontier is an Endless Wall of Points* (2007) Koester transposes drawings Michaux made under the influence of mescaline to the medium of film,

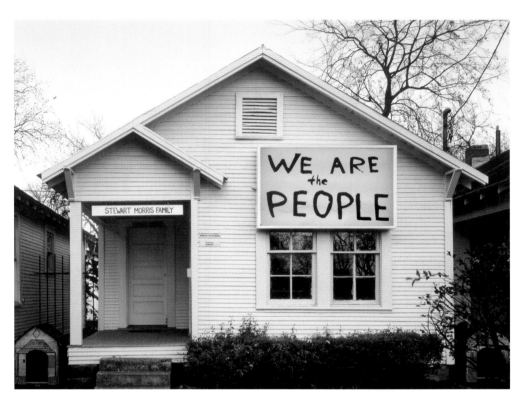

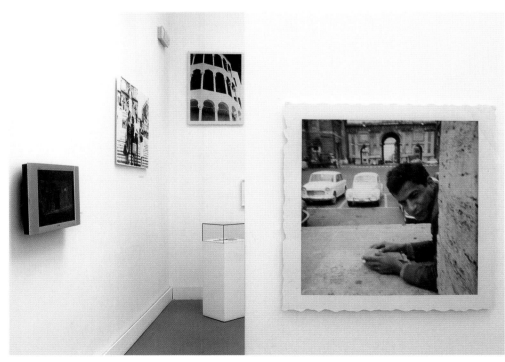

FACING PAGE, ABOVE:
JOACHIM KOESTER
One + One + One, 2006.
Double video projection with
sound, interacting randomly.

FACING PAGE, BELOW:
PATTY CHANG
Untitled (Eels), 2001.
Color video with sound,
16 minutes.

ABOVE:
SAM DURANT
We Are The People, 2003.
Electric sign with vinyl
text, 121.9 x 195.6 x 27.9 cm.
Installation view,
Project Row Houses,
Houston, 2003.

BELOW:
EMILY JACIR
Material for a film,
2005–ongoing. 3 sound
pieces, 1 video, texts,
photographs, and archival
material, dimensions
vary with installation.
Installation view, 52nd
Venice Biennale, 2007.

animating the imagery in an effort to capture something of the artist's psychotropic experiences. For several projects, the artist sought out the long-abandoned, dilapidated communal home known as the Abbey of Thelema, established by British occultist Aleister Crowley (1875–1947) in Cefalù, Sicily. Koester's film *One + One + One* (2006), filmed at the abbey, traces a cycle of cultural influences between Crowley, the counterculture of the sixties that found inspiration in his teachings, and the filmmaker Jean-Luc Godard. The title references Godard's 1968 film *One Plus One*, which featured the Rolling Stones and was retitled *Sympathy for the Devil* for its American release in

1970 after the band's song. In Koester's film, a girl taps out the drumbeat of this song in an added layer of reference.

In his strikingly visual "events-as-sculpture," Swiss artist Roman Signer poses absurd experiments using familiar objects and materials in unexpected ways. Seemingly simple, though often technically complex, these events explore the potential of the materials and forces of nature that are part of his creative process. Signer uses such elements as gravity, wind, gunpowder, and fireworks as "animating forces" that ultimately determine a final sculptural form within the situation he has constructed. The outcomes illustrate the poetic potential of these powerful forces, as in the action-event *Water Boots* (1986), in which hoses are used to propel water through the soles of rubber boots, forming the ghost of a disintegrating figure that is captured on film. Through events of this kind, Signer extends the notion of sculpture beyond its traditionally static character, incorporating time as a medium as well as the momentary alteration of an environment.

Each artist on this year's shortlist strives to reveal misconceptions that are prevalent in historical memory, as well as in our understanding of gender, ethnicity, the creative economy, and even the potential of materials. They continue the modern tradition of expanding our notions of what constitutes art in compelling endeavors that incorporate archival research, performance, and quasi-scientific experiments.

ROMAN SIGNER
Water Boots
(Wasserstiefel), 1986.

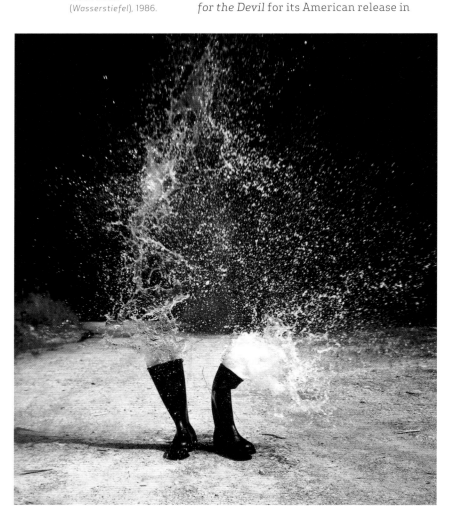

SPRING/SUMMER 2008

PATTY CHANG

ULD"

PA
CH

"TOUCH WOULD"

LIZA JOHNSON

Three different translators each sit alone in brightly lit rooms, reading out loud from an oversize volume. The text, a 1928 interview by the scholar and translator Walter Benjamin with the film actress Anna May Wong, has never been published in English. We see each reader translate, pause, gesture. The video, Patty Chang's *A Chinoiserie Out of the Old West* (2006), cuts from one translator to the next, phrase by phrase. We can piece together, poetically, that Benjamin is smitten by Wong, and apparently also taken with her Chineseness, to the point that our interpreters halt and struggle when Benjamin describes Wong's name as "colorful" and made of "small letters like those in a cup of tea that open themselves up to, like, a full moon flower."

In most instances, the three translators' interpretations correspond to one another. But each one arrives at an ambivalent turn, a passage that is impossible to pin down. They agree on how to translate Benjamin's assertion that "May Wong can no longer imagine her existence (or being) without film." They agree on the question he asks her: "What medium of expression would you take hold of if you couldn't make films any more?" But the translation of Wong's answer is not so simple, even though it is written in English within the German text. As one translator offers, "Her only answer is 'touch wood'—which is beautifully spelled w-o-u-l-d." The translator then explains that the small group present for the interview knocks on the table.

If we imagine Benjamin's question to mean, "what if you couldn't make films anymore," then we can hear Wong offering the protective apotrope: "Touch wood!" as if to say, "Heaven forbid! Who among us can imagine our existence without cinema? What would it mean to try to imagine a world in which we did not constitute our very selves through its logic?" But, in another translation offered to us in Chang's video, we must consider whether Wong responded to another version of the question, with the emphasis on "What else would be your medium?" To this, she offers a conditional answer: "Touch would."

Touch would? Touch is a sense rather than a medium. Would it be possible to take this seriously as an answer? Clearly, one of the other translators does. And Benjamin himself was emphatic about the difference between a text and its translation, writing that "no translation would be possible if in its ultimate essence it strove for likeness to the original. For in its afterlife—which could not be called that if it were not a transformation and renewal of something living—the original undergoes a change."[1] So what, literally, might Wong mean?

Chang's video obliges us to imagine ways that touch could be a real working method or means of expression—a model similar to Benjamin's own relational, haptic approach to cinema, space, perception, and the body.[2] Like much of the art tradition from which

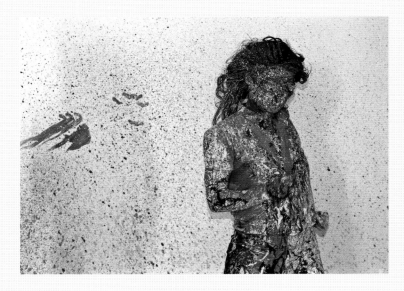

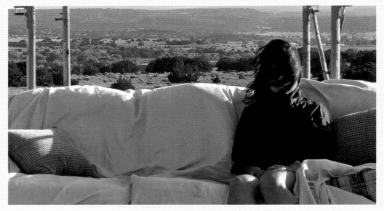

of sight. We see her writhing with eels in her blouse (*Untitled (Eels)*, 2001), or falling onto an unreliable version of a suburban yard that undulates like a waterbed (*At a Loss*, 2000). Chang presents relationships that are not just about looking, but about feeling, ingesting. In *Fountain* (1999), for example, she one-ups Narcissus, not just looking at her own image, but drinking it, excessively—in some performances, for forty minutes. Even the more recent *Fan Dance* (2003) is a tactile, endurance-testing version of action painting, where paint is thrown by an assistant into a fan and blown onto Chang's body. Symbolic and real at the same time, Chang's body is never outside ideology, never outside gender or the persistent operations of Chinoiserie. Simultaneously, her body remains material, a stubborn substance, intransigent, real.

If we might be tempted to read these works as the entertaining spectacle of Chang's body and its masochistic endurance—like a high-art episode of the television show *Jackass*—her 2004 projects remind us otherwise. Chang says: "It is difficult when people say they empathize with me going through something in my performances, and that is what they want to continue seeing. As if I was a recurring character and it is some sort of soap opera they are watching."[5] To read the work as pure spectacle is to forget that masochism is not just a display, but a relationship. Touch is a two-way phenomenon; the tables can be turned, or, more accurately, they have always been turned. In the multichannel *Sorority Stage Fright* (2004), Chang asks California sorority girls to remake her 2002 binge-and-purge performance, *Stage Fright*. In *Chez les Grecs* (2004), she invites men in Greece to shave *their* pubic hair blindfolded. The roles shift when they are translated by new bodies, but the same relationships are at stake when Chang moves her body to the other side of the camera.

Chang emerges, Wong's elevation of touch puts "the sentient body at the center of knowing."[3] If we understand Wong to say that "touch would" be her medium, then perhaps she suggests that touching the world is a form of what Chang calls passionate interaction[4] —a mode of engagement that risks the putative safety of optical distance for a relational, reciprocal, tactile kind of critical closeness.

ABOVE:
Fan Dance, 2003.
C-print, 50.8 x 61 cm

BELOW:
Condensation of Birds,
2006. Color video with
sound, 30 minutes.

Tactile, passionate interaction is not hard to observe in Chang's earliest works involving her own body. In her first performance piece *Shaved (At a Loss)* (1998), she is literally blindfolded, feeling her way onto the stage, shaving her pubic hair without the benefit

Since 2005, Chang has deployed this tactile, critical closeness in a series of extended

site-specific projects, "passionately interacting" with landscapes, people, and geopolitical relationships beyond the psychic ones that she explores in her earlier work, setting cultural fantasies in motion in a concrete documentary environment. As before, she stages relationships that traffic in symbol without stepping outside of physical reality, but now in an expanded landscape, a particular time and place. In *Shangri-La* (2005), Chang travels to China's Yunnan Province, to Zhongdian, a town that has recently renamed itself after James Hilton's fictional Himalayan paradise from 1933. She hires local laborers to create imagined mountainscapes out of Styrofoam, mirrors, and even wedding cake. The props become prosthetic extensions of her presence, and she sends them moving on a flatbed truck across the real geography and concrete effects of Western fantasies about China and Tibet.

In *Condensation of Birds* (2006), Chang throws herself into the literal and cultural landscape of Santa Fe, New Mexico. She takes as a point of departure a news story about a U.S. nuclear submarine that crashed into an undersea mountain near Guam, where oceanic navigators traditionally rely on elements like concentrations of seaweed, algae, or birds for orientation, rather than maps of fixed land masses. Chang reads this real event as a metaphor, both for perceptual differences between East and West and for psychoanalytic ideas about submergence, condensation, and displacement. Then she reconstructs the metaphor as something tangibly real—a skeletal surrogate submarine built to scale out of scaffolding in the New Mexico desert. She engages a blonde, Western guru who leads others in forms of Eastern non-dualistic thinking. Chang immerses herself in the spiritual leader's environment, then reciprocally immerses the guru, physically and mentally, in her "submarine." In the process, she also literally touches the environment with her body, engulfed by a parachute or even by her own hair whipping in the desert wind.

The physical, literal touch of Chang's body is more removed in *Flotsam Jetsam* (2008), but here the relationships suggested by a working method of passionate interaction are arguably at their most developed. A collaboration with David Kelley, the video is shot near the Three Gorges Dam on the Yangtze River. The landscape of *Flotsam Jetsam* bears visible traces of the dam's massive construction and destruction, the flooding of cities, and the displacement of millions of people. But cool visual observation of these traces on the surface of the site is inadequate to the artists' goals. Chang and Kelley again commission the construction of a submarine, insisting that its clumsy, material presence be hammered, shaved, painted, and dragged across the landscape in question—an embodiment through which an idea can touch the world.

Like many of Chang's recent, longer projects, *Flotsam Jetsam* uses a grammar of the moving image grounded in wide shots that frame the landscape and last for a long duration, something like the signature long take of postwar Italian neorealism that was presumed to produce a kind of "realness" by refusing to direct the eye. In China, in the same postwar period, the long take could also be understood partly as a nod to tradition, to "the aesthetic of *you* or unrestrained roaming found in traditional literature, and especially in scroll painting."[6] Chang and Kelley, like many contemporary film directors internationally—such as Jia Zhangke, Abbas Kiorastami, and Bela Tarr—press the long take beyond is putative realism, towards what Jason McGrath calls "an intriguing kind of formalism," the "ostensible opposite" of its use in neorealism.[7] The visual style of *Flotsam Jetsam* suggests a documentary relation to the real at the same time as revealing the conventions we use to produce "realness."

It is at least partly through this grammar that we experience a degree of formal distance in dialectic with the artists' tactile, critical closeness, and the performance styles in the piece echo this. Working with

Chinese actors, Chang and Kelley ask company members to describe dreams they have had, and then reenact them in the landscape. The erotics of touch can also resemble an ethics of encounter. Chang and Kelley reach towards their actors' inner lives without allowing us to believe that the subjects can be transparently understood. The actors perform their dreams in highly stylized forms—even occasionally in the style of classical Chinese opera. We see a woman's dreams acted out in an enormous shipyard by a man dressed as a tiger, but can we say that we understand her? And yet the artists seem to ask, if translation is doomed to fail, does that excuse us from trying?

Flotsam Jetsam is an outwardly directed effort to translate or reveal realities that have been submerged (literally). It is also a constant reflection on the cinematic means of this revelation. (Who among us can think of ourselves without cinema?) The video is itself difficult to distinguish from cinema, even as it reflects on the failures of cinematic forms—Realist, documentary, Chinese epic cinema—to translate the real. What would be the medium you would take hold of if you couldn't express yourself in received forms

of cinema? In cinematic experiments, in performance, or as a method of being in the world, for Chang, touch would.

1. Walter Benjamin, "The Task of the Translator: An Introduction to the Translation of Baudelaire's *Tableux parisiens*," in *Illuminations*, ed. Hannah Arendt, trans. Harry Zohn (New York: Schocken Books, 1968), p. 73.

2. For example, Guiliana Bruno asks us to consider Benjamin's comparison of "the cameraman's eye to the hands of a surgeon who cuts into the body, thus impressing on celluloid the force of a vision that 'operates' a transformation with touch." Guiliana Bruno, *Atlas of Emotion: Journeys in Art, Architecture, and Film* (New York: Verso, 2002), p. 257.

3. Peggy Phelan, "The Returns of Touch: Feminist Performances, 1960–80" in *Wack! Art and the Feminist Revolution*, ed. Lisa Gabrielle Mark (Los Angeles: Museum of Contemporary Art, 2007). Phelan offers the wonderful example of Valie Export's 1968 piece *Tap and Touch Cinema* (*Tapp und Tast Kino*), in which Export wore a Styrofoam box outside an experimental film festival, inviting spectators to grasp inside for, but not look at, her naked breasts. In her broader argument, Phelan usefully distinguishes the operations of touch from the limiting visual operations of gazing and voyeurism made familiar by 1970s psychoanalytic film theory. But Phelan does not acknowledge later feminist film theories that more closely resemble her own phenomenology of touch. Most notably, Vivian Sobchack, in her influential text *The Address of the Eye: A Phenomenology of Film Experience* (Princeton: Princeton University Press, 1992), provides precisely the kind of fundamentally relational theory of embodied vision for which Phelan calls. Much consideration of the haptic that has followed in film theory and criticism, including my own, is indebted to Sobchack's important work, which acknowledges the entire body as present in perceptual and cinematic encounter.

4. Patty Chang as quoted in, "Interview with Patty Chang," by Eve Oishi, *Camera Obscura* 54, vol. 18, no. 3 (2003), p. 120.

5. Quoted in Russell Ferguson, "Paradise on Earth," in *Patty Chang: Shangri-La*, exh. cat. (Los Angeles: Hammer Museum, 2005), p. 27.

6. Carolyn FitzGerald, "*Spring in a Small Town*: Gazing at Ruins" *Chinese Films in Focus 2*, ed. Chris Berry (London: British Film Institute, forthcoming). FitzGerald is describing Lin Niantong's thoughts on the long take from his book *The Roaming Lens* (Jingyou, Hong Kong: Su ye, 1985). See also Chris Berry's essay in the same volume ("Watching Time Go By: Narrative Distension, Realism, and Post Socialism in Jia Zhangke's *Xiao Wu*") which is extremely useful for considering the ways that the meaning of the long take is historically contingent.

7. Jason McGrath, "The Cinema of Jia Zhangke," in *The Urban Generation: Chinese Cinema and Society at the Turn of the Twenty-First Century*, ed. Zhang Zhen (Durham, North Carolina: Duke University Press, 2007).

PATTY CHANG AND DAVID KELLEY
Flight Attendant (from *Flotsam Jetsam*), 2007. C-print, 101.6 x 127 cm

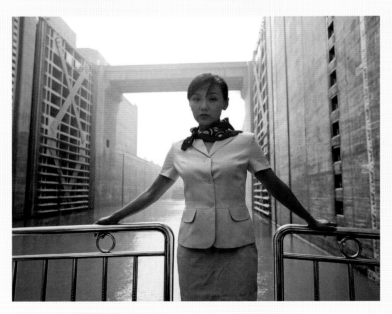

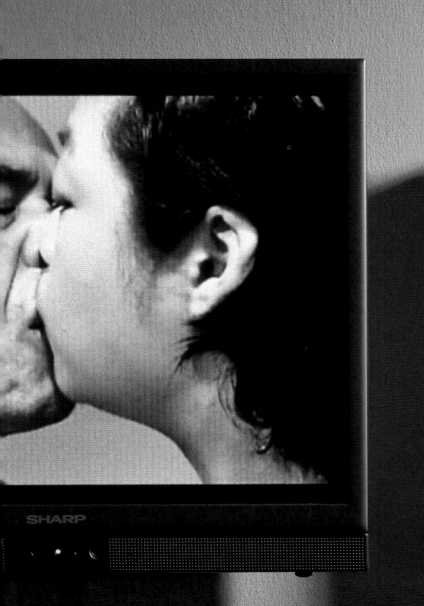
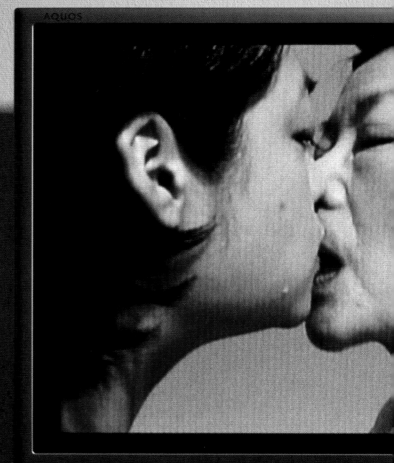

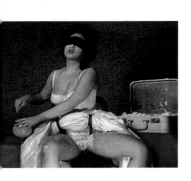

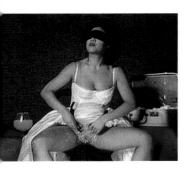

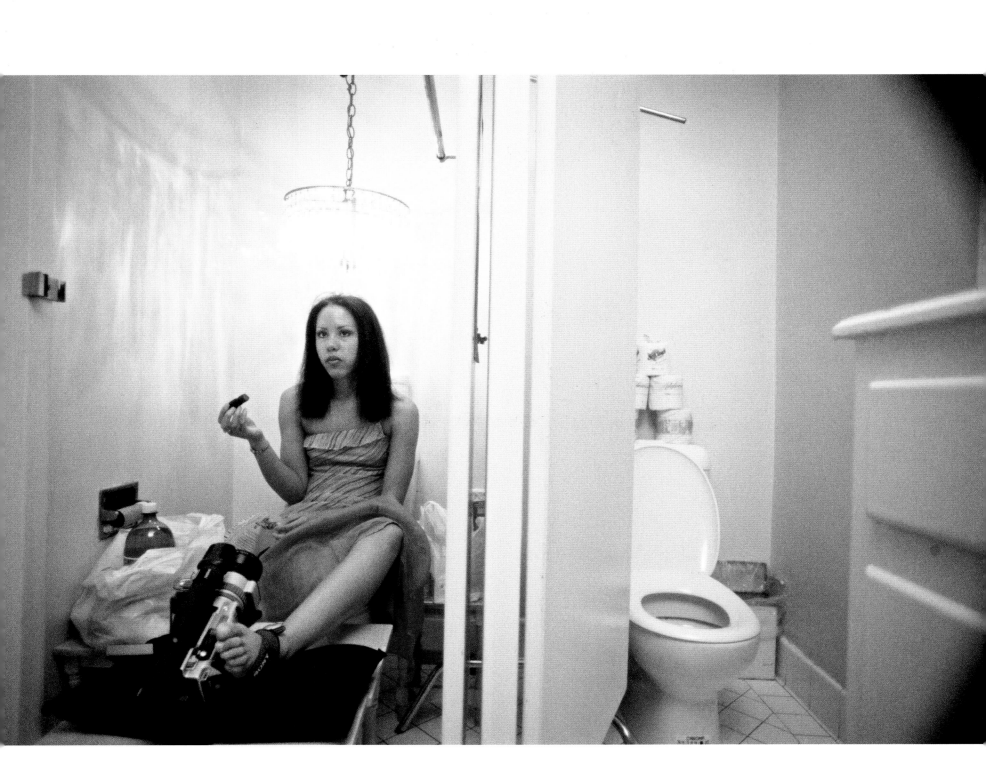

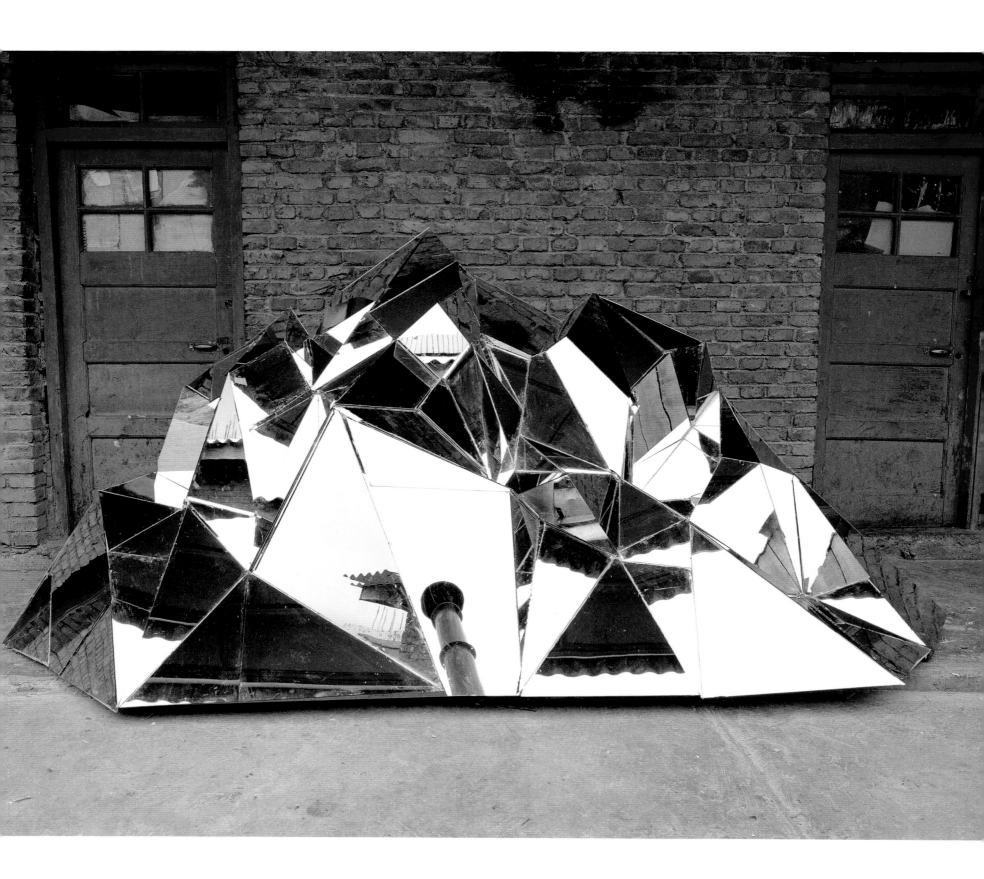

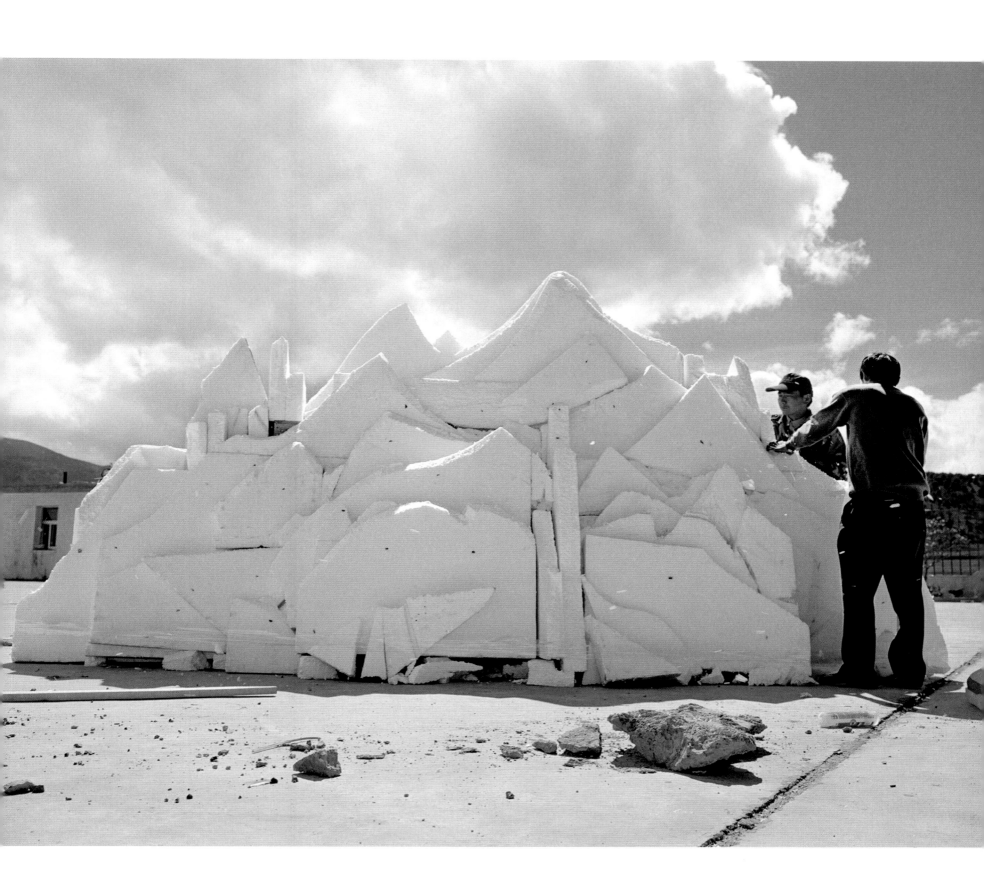

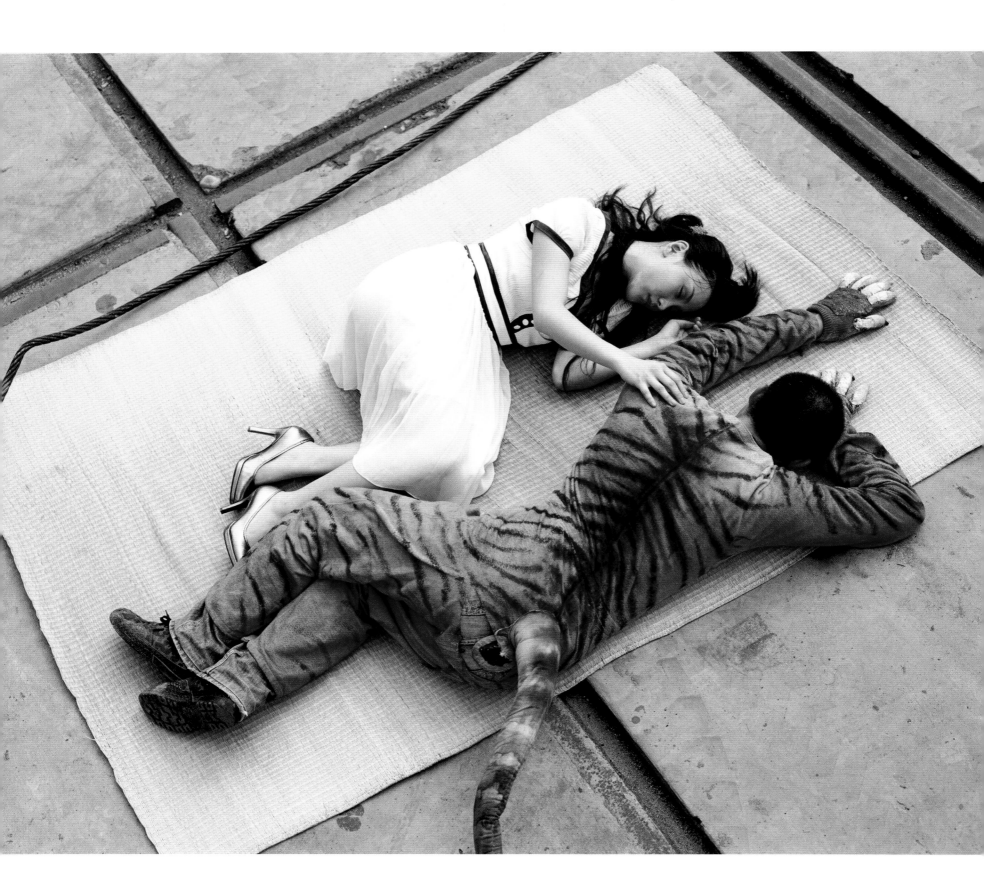

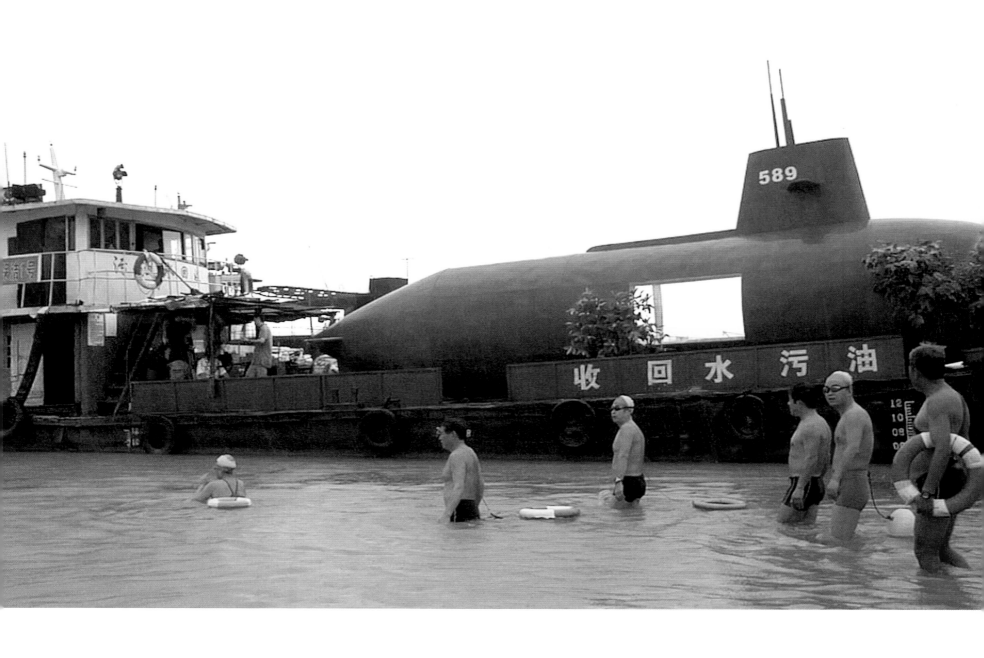

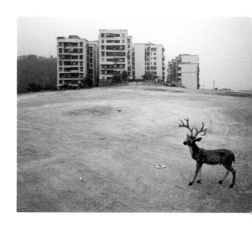

SAM
DURANT

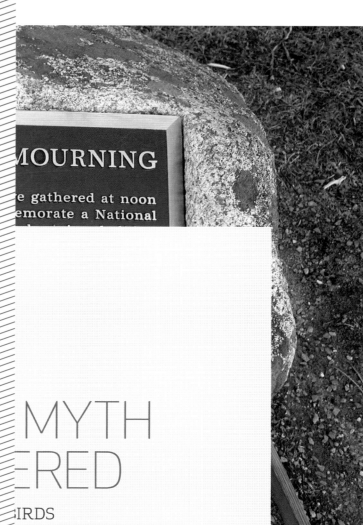

MYTH
ERED

BIRDS

SA
DU

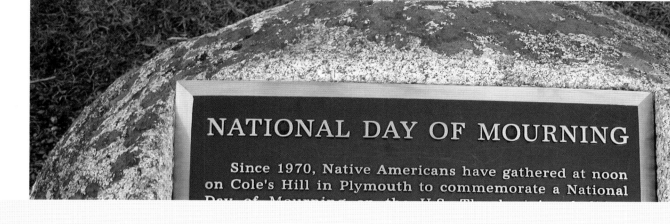

NATIONAL DAY OF MOURNING

Since 1970, Native Americans have gathered at noon
on Cole's Hill in Plymouth to commemorate a National

AMERICA'S FOUNDING MYTH RECONSIDERED

SHANNA KETCHUM-HEAP OF BIRDS

You the white man are celebrating an anniversary. We the Wampanoags will help you celebrate in the concept of a beginning. It was the beginning of a new life for the Pilgrims. Now, 350 years later, it is the beginning of a new determination for the original American: the American Indian.
—Wamsutta (Frank B.) James,
 "Suppressed Speech" [1]

Myth is history's alter ego, accompanying it like a shadow wherever it goes: indeed, paradoxically, myth is the best measure of history's own success.
—F.R. Ankersmit, "The Sublime Dissociation of the Past: Or How to Be(come) What One is No Longer" [2]

The anniversary that Wamsutta James spoke of over thirty years ago refers to the first Thanksgiving of 1621 that, according to popular American belief, had the Pilgrims sharing a bountiful harvest with friendly local Indians. As the perennial event marking the foundation of America's national heritage, the Pilgrims' landing in 1620 continues to be celebrated and memorialized across the nation, particularly in the town of Plymouth, Massachusetts, where a Thanksgiving Day parade takes place every year. In contrast, in 1970, the United American Indians of New England (UAINE) declared Thanksgiving Day a National Day of Mourning to counter the mythological treatment of America's

historical past by Pilgrim descendants. When drawing upon narratives written by the first Pilgrims, James's "Suppressed Speech" exposed the imperialistic overtones that accurately described the settlement of lands and the exploitation of indigenous peoples through the violations of their freedom and human rights.

As a way of extending the critique James forged years ago in alliance with UAINE, contemporary artist Sam Durant offers a complex analysis of the historical utilization of American monuments and their myths with his recent project, *Scenes from the Pilgrim Story: Myths, Massacres, and Monuments* (2006). As one of the most visible examples of the institutionalization of history, American monuments generated by the heritage industry are often ossified constructions that, like statues, are "polished up solely so as to be able to gleam back resplendently into the eyes of those that behold [them]." [3] For that reason, Durant's exhibit operates as a type of revisionist social history that reexamines Indian-white relations constructed by those in power who continue to invest, define, and put to work the Pilgrim Story in and around the town of Plymouth. For Durant, who grew up in Massachusetts not far from Plymouth Rock, monuments such as these seem to serve the primary purpose of justifying the conquest of indigenous peoples by white settlers. [4]

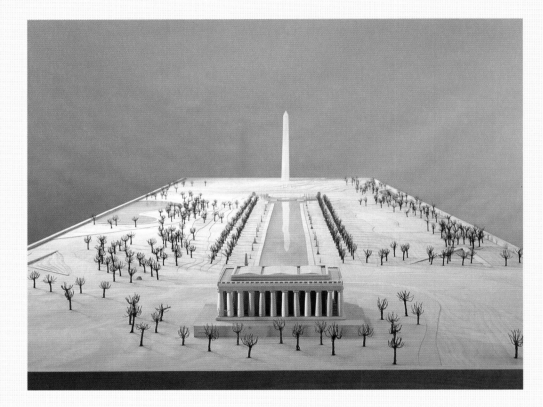

ABOVE AND FACING PAGE:
Proposal for White and Indian Dead Monument Transpositions, Washington, D.C., 2005. MDF, fiberglass, foam, enamel, acrylic, basswood, balsa wood, birch veneer, and copper; 30 monuments: dimensions variable; architectural model, 121.9 × 381 × 40.6 cm, Installation views, Paula Cooper Gallery, New York, 2005.

Consequently, Durant's artistic practice often involves a critique of institutional hierarchies to disclose how monuments function as sites of memory that are "meaningful and legible only within the currencies [within] which they were comprised."[5] In a recent project titled *Proposal for White and Indian Dead Monument Transpositions, Washington, D.C.* (2005), the artist demonstrates how the numerous monuments, markers, and memorials across the U.S. not only commemorate massacres of indigenous peoples during the colonization of North America, but duly reflect the conflicts and violence representative of the formation of the Republic.[6] As one critic put it, "Durant supplies what's missing between the memorials: the Indian Wars that were also genocide."[7] It is this aspect of Durant's projects that involves an interrogation of America's historical narratives to allow the indigenous voice to be heard long enough for viewers to recognize the mytho-

logical constructions that are often touted as historical fact. By exploring the diversity of meanings and histories intrinsic to the Pilgrim myth, Durant demonstrates how subjects and objects are appropriated and historicized according to dominant political beliefs encompassing modern concepts of nation and ethnicity in America.

In one installation titled *Subject/Position/ Object/Placement (Pilgrim Monuments: Massasoit, Metacomet, and Plymouth Rock)* (2006), a range of monuments are recontextualized to address, both symbolically and geographically, the actual location of Pilgrim-related monuments and how they work. A fiberglass replica of the famed Plymouth Rock is placed on the floor with the date "1620" staring up at the viewer. Standing on the other side of the rock, opposite the viewer, is the wax figure of an Indian male steadily gazing into space with his back to the viewer, perhaps referencing

NATIONAL DAY OF MOURNING

Since 1970, Native Americans have gathered at noon
on Cole's Hill in Plymouth to commemorate a National

the Massasoit monument located on Cole's Hill. Included in the scene is a freestanding sign dedicated to Metacomet (King Philip) and King Philip's War (1675–76), with a transcription of the actual text from the plaque located in Post Office Square. In considering the placement of his own replicas in the gallery space, Durant is well aware of the fanfare surrounding the actual objects and the power invested in them to define and put to work the important aspects of the Pilgrim myth. As one of the most popular destinations for visitors every year, the town of Plymouth advertises each of these monuments on a tour as "must see" attractions situated strategically in the historic district.

In another piece, titled *Pilgrims and Indians, Planting and Reaping, Learning and Teaching* (2006), Durant has placed two scenes on either side of a sixteen-foot circular platform that is motorized and rotates continuously at a leisurely pace. On both sides of the eight-foot wall that bisects the moving platform, several figures and props are assembled to replicate two scenes that were on display at the Plymouth National Wax Museum. One scene depicts the English-speaking Indian, Squanto (Tisquantum), teaching the Pilgrims to fertilize their corn with fish to ensure a good harvest in the fall. As indicated by Durant, "this scene has served a centrally important role in the Pilgrim story; it acknowledges that, were it not for the help of sympathetic Indians, the Pilgrims would have perished soon after their arrival."[8] To be sure, the Pilgrims survived their first winter solely because they received tremendous aid from local Indians, particularly Squanto and other members of the Wampanoag Confederacy.

However, despite the humanitarian efforts extended to the Pilgrims, conflicts ensued over the immigrant group's desire to acquire more land as well as their imposition of repressive values that championed Christian beliefs through missionary

efforts. In contrast to the friendly planting and reaping portrait with Squanto, the adjacent scene on the other side of the wall is attuned to the tyrannical features of the Pilgrims' progress, because it depicts Captain Miles Standish beating an Indian with a club. The Indian man, Pecksuot, is on all fours, with a knife in his chest, his face turned downward with tomahawk still in hand, while Standish hovers menacingly over him in triumph. According to Durant, "the scene had been removed from display [at the wax museum] in the 1970s for obvious reasons—it made Indian-Pilgrim relations all too clear."[9] In fact, Durant had to reconstruct the scene based on a postcard he found in the museum's basement when conducting research.

Radical challenges to the Pilgrim myth have been courageously carried out by UAINE members with demonstrations and protests taking place in Plymouth during the Thanksgiving Day parade. In various ways, Durant extends this type of protest to the gallery space by interrogating the myth with indigenous perspectives that offer a counterhistory. Durant's decision to confront viewers with historical facts such as colonialism and genocide reveals the true intentions behind the construction

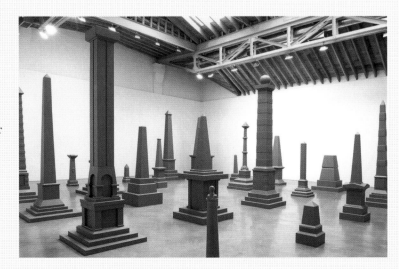

*Proposal for White and
Indian Dead Monument
Transpositions,
Washington, D.C.* 2005
(detail). MDF, fiberglass,
foam, enamel, acrylic,
basswood, balsa wood,
birch veneer, and copper;
30 monuments: dimensions
variable; architectural
model, 121.9 x 381 x 40.6 cm
Installation view,
Paula Cooper Gallery,
New York, 2005

of the Pilgrim story, because the omissions are inevitably made for a reason. Durant's acknowledgment of the traumatic memories held by native people also points to the "forgetfulness" typical of celebrated myths. In particular, Pilgrim identity is dramatized into a story that associates the beginning of time with the year 1620. All that preceded that point in time is discarded, and experience of the world is confined to a cultural and historical past that makes the myth work every year. As such, the history of indigenous peoples' existence in America before 1620, including the traumatic events following that date, is unsuitable for a story that abandons reality on a regular basis in

favor of yearning for a nostalgic past that is beyond time—or dissociated into a sublime understanding of history.

1. Wamsutta (Frank B.) James, "Suppressed Speech," to have been delivered at the Commonwealth of Massachusetts banquet celebrating the 350th anniversary of the landing of the Pilgrims, Plymouth, Massachusetts, September 10, 1970. http://www.uaine.org/wmsuta.htm.

 This essay draws from my essay "On Legitimizing the Body Politic: America's Founding Myth Reconsidered," in *Sam Durant: Scenes from the Pilgrim Story: Myths, Massacres, and Monuments* (Boston: Massachusetts College of Art and Design, 2007), pp. 12–25.

2. F.R. Ankersmit, "The Sublime Dissociation of the Past: Or How to Be(come) What One is No Longer," *History and Theory* 40, no. 3 (October 2001), pp. 295–323.

3. Sigurdur Gylfi Magnússon, "Social History as 'Sites of Memory'? The Institutionalization of History: Microhistory and the Grand Narrative," *Journal of Social History* 39, no. 3 (Spring 2006), p. 893.

4. Sam Durant, interview by John LeKay, "Sculpture: Sam Durant," *Heyoka Magazine* 3 (Winter 2006). http://www.heyokamagazine.com/HEYOKA.3.SCULPT. SAM%20DURANT.htm.

5. Similarly, in *The Burden of Representation: Essays on Photographies and Histories* (Basingstoke: Macmillan, 1988), p. 63, John Tagg examines the conjuncture of state institutions with specific forms of photographic practice to determine the diversity in meanings of photography.

6. Sam Durant, *Proposal for White and Indian Dead Monument Transpositions, Washington, D.C.* (New York: Paula Cooper Gallery, 2005), p. 5.

7. Jerry Saltz, "Art & Photo: Blood Monument," *The Village Voice*, October 14, 2005. http://www.villagevoice.com/ art/0542,saltz,68921,13.html.

8. Sam Durant, "General Statement: Scenes from the Pilgrim Story: Myths, Massacres and Monuments," unpublished artist statement, 2006.

9. Ibid.

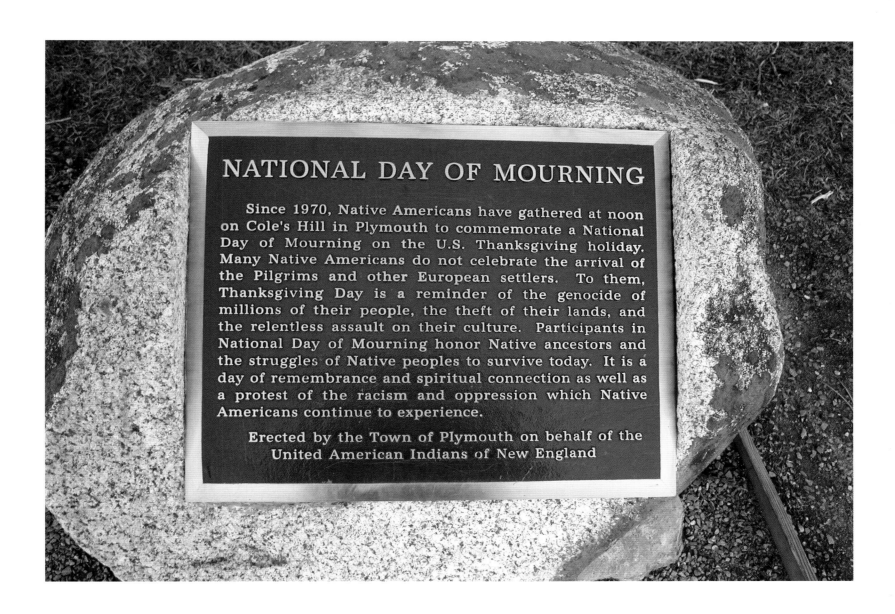

NATIONAL DAY OF MOURNING

Since 1970, Native Americans have gathered at noon on Cole's Hill in Plymouth to commemorate a National Day of Mourning on the U.S. Thanksgiving holiday. Many Native Americans do not celebrate the arrival of the Pilgrims and other European settlers. To them, Thanksgiving Day is a reminder of the genocide of millions of their people, the theft of their lands, and the relentless assault on their culture. Participants in National Day of Mourning honor Native ancestors and the struggles of Native peoples to survive today. It is a day of remembrance and spiritual connection as well as a protest of the racism and oppression which Native Americans continue to experience.

Erected by the Town of Plymouth on behalf of the United American Indians of New England

METACOMET (KING PHILIP)

After the Pilgrims' arrival, Native Americans in New England grew increasingly frustrated with the English settlers' abuse and treachery. Metacomet (King Philip), a son of the Wampanoag sachem known as the Massasoit (Ousamequin), called upon all Native people to unite to defend their homelands against encroachment. The resulting "King Philip's War" lasted from 1675-1676. Metacomet was murdered in Rhode Island in August 1676, and his body was mutilated. His head was impaled on a pike and was displayed near this site for more than 20 years. One hand was sent to Boston, the other to England. Metacomet's wife and son, along with the families of many of the Native American combatants, were sold into slavery in the West Indies by the English victors.

UNITED AMERICAN INDIANS OF NEW ENGLAND

Object But some will say, what right have I to go live in the heathens' country?

Answ. Letting pass the ancient discoveries, contracts and agreements which our Englishmen have long since made in those parts, together with the acknowledgment of the histories and chronicles of other nations, who profess the land of America from the Cape de Florida unto the Bay of Canada (which is south and north three hundred leagues and upwards, and east and west further than yet hath been discovered) is proper to the King of England—yet letting that pass, lest I be thought to meddle further than it concerns me, or further than I have discerning, I will mention such things as are within my reach, knowledge, sight and practise, since I have travailed in these affairs.

Reas. 2. And first, seeing we daily pray for the conversion of the heathens, we must consider whether there be not some ordinary means and course for us to take to convert them, or whether prayer for them be only referred to God's extraordinary work from heaven. Now it seemeth unto me that we ought also to endeavor and use the means to convert them, and the means cannot be used unless we go to them or they come to us; to us they cannot come, our land is full; to them we may go, their land is empty.

Reas. 3. This then is a sufficient reason to prove our going thiter to live lawful: their land is spacious and void, and there are few and do but run over the grass, as do also the foxes and wild beasts. They are not industrious, neither have art, science, skill or faculty to use either the land or the commodities of it, but all spoils, rots, and is marred for want of manuring, gathering, ordering, etc. As the ancient patriarchs therefore removed from straiter places into more roomy, where the land lay idle and waste, and none used it, though there dwelt inhabitants by them, (as Gen. 13:6, 11, 12, and 34:21, and 41:20), so it is lawful now to take a land which none useth, and make use of it.

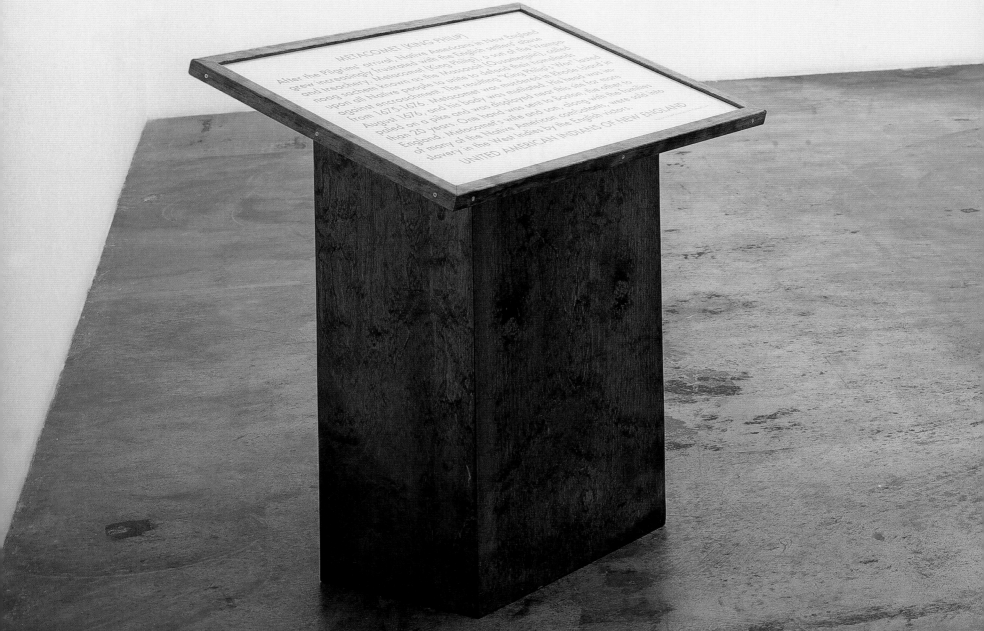

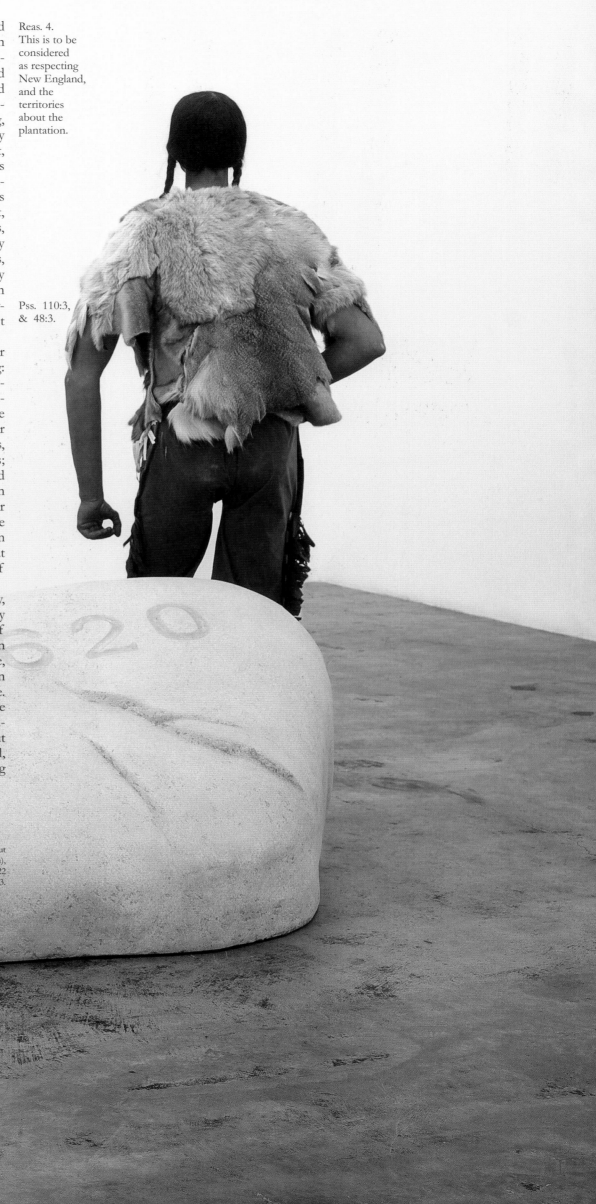

And as it is a common land or unused, and undressed country, so we have it by common consent, composition and agreement, which agreement is double. First, the imperial governor Massasoit, whose circuits in likelihood are larger than England and Scotland, hath acknowledged the King's Majesty of England to be his master and commander, and that once in my hearing, yea, and in writing, under his hand to Captain Standish, both he and many other kings which are under him, as Paomet, Nauset, Cummaquid, Narraganset, Nemasket, etc., with divers others that dwell about the bays of Patuxet and Massachusets. Neither hath this been accomplished by threats and blows, or shaking of sword and sound of trumpet, for as our faculty that way is small, and our strength less, so our warring with them is after another manner, namely by friendly usage, love, peace, honest and just carriages, good counsel, etc., that so we and they may not only live in peace in that land, and they yield subjection to an earthly prince, but that as voluntaries they may be persuaded at length to embrace the Prince of Peace, Christ Jesus, and rest in peace with him forever.

Secondly, this composition is also more particular and applicatory, as touching ourselves there inhabiting: the emperor, by joint consent, hath promised and appointed us to live at peace where we will in all his dominions, taking what place we will, and as much land as we will, and bringing as many people as we will, and that for these two causes. First, because we are servants of James, King of England, whose the land (as he confesseth) is; second, because he hath found us just, honest, kind and peaceable, and so loves our company; yea, and that in these things there is no dissimulation on his part, nor fear of breach (except our security engender in them some unthought of treachery, or our uncivility provoke them to anger) is most plain in other relations, which show that the things they did were more out of love than out of fear.

It being then, first, a vast and empty chaos; secondly, acknowledged the right of our sovereign king; thirdly, by a peaceable composition in part possessed of divers of his loving subjects, I see not who can doubt or call in question the lawfulness of inhabiting or dwelling there, but that it may be as lawful for such as are not tied upon some special occasion here, to live there as well as here. Yea, and as the enterprise is weighty and difficult, so the honor is more worthy, to plant a rude wilderness, to enlarge the honor and fame of our dread sovereign, but chiefly to display the efficacy and power of the Gospel, both in zealous preaching, professing, and wise walking under it, before the faces of these poor blind infidels.

Excerpt from "Reasons and Considerations touching the lawfulness of removing out of England into the parts of America," written by R.C. (presumably Robert Cushman), *Mourt's Relation: A Journal of the Pilgrims at Plymouth*, Edited from the original text of 1622 by Dwight B. Heath, (Bedford, Massachusetts: Applewood Books, 1963), pp. 91–93.

Reas. 4.
This is to be considered as respecting New England, and the territories about the plantation.

Pss. 110:3, & 48:3.

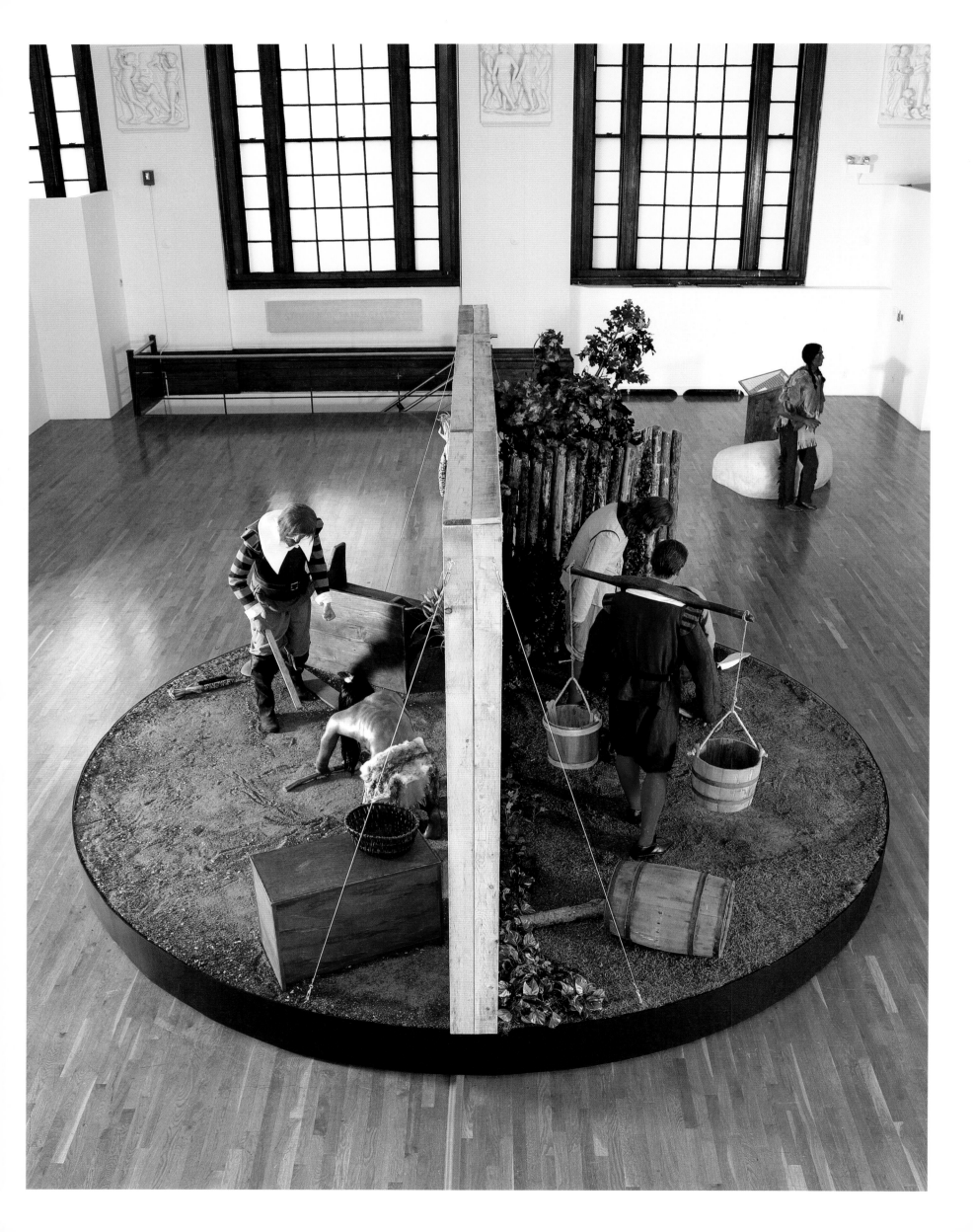

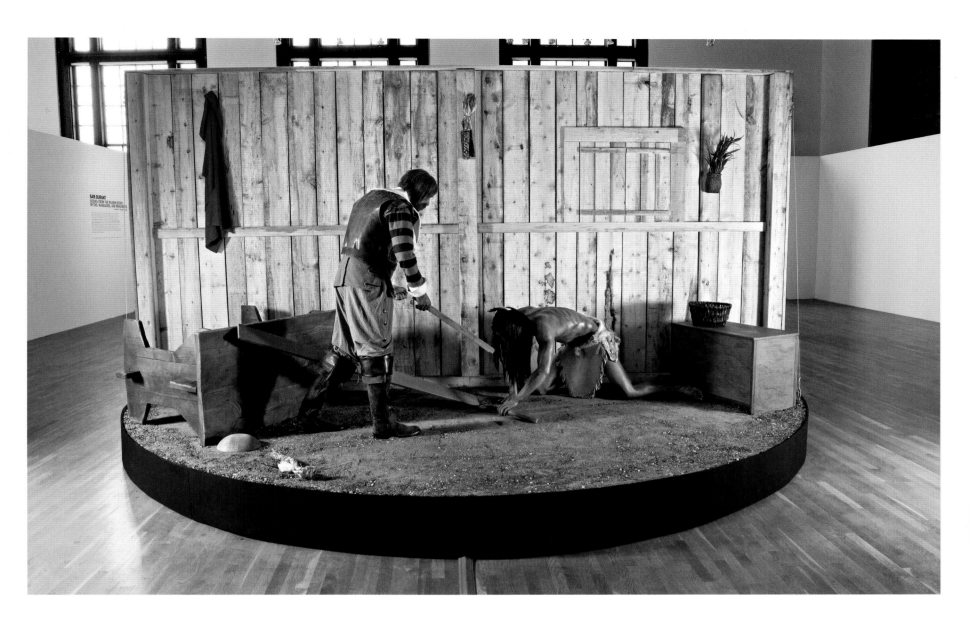

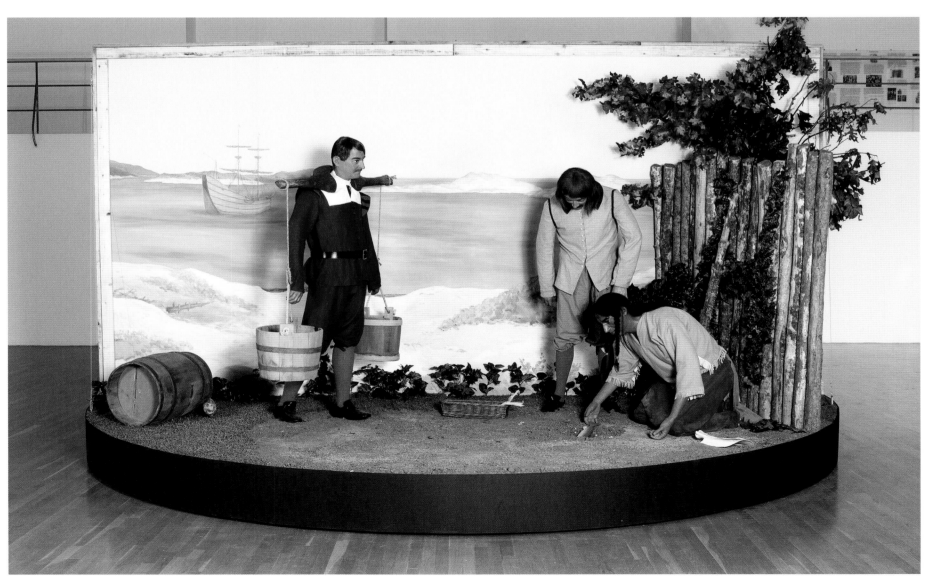

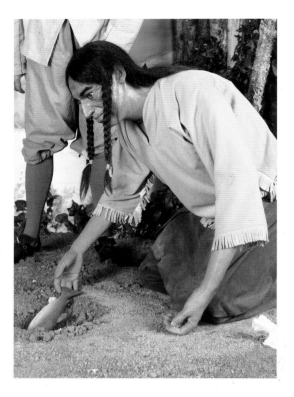

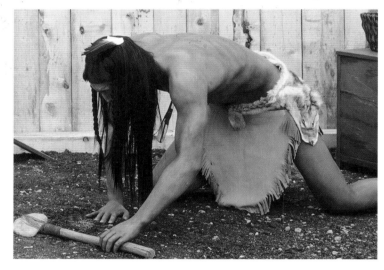
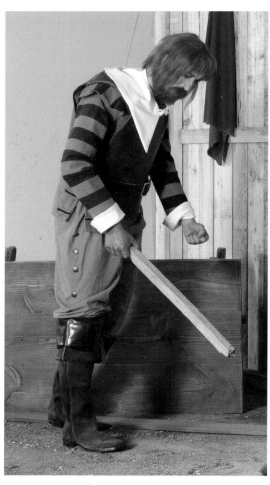

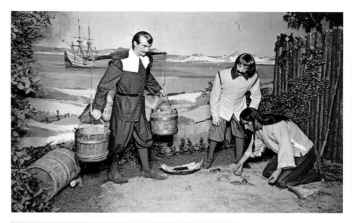

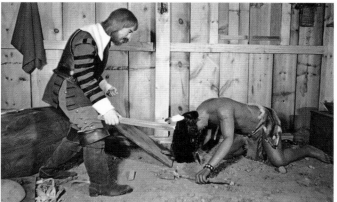

PLYMOUTH NATIONAL WAX MUSEUM
Plymouth, Massachusetts
COOPERATION WITH THE INDIANS
CORN PLANTING — 1621
To Squanto, another English speaking Indian and friend of Samoset, the Pilgrims owed a debt of gratitude. He taught them how to plant their corn in small, well spaced hillocks, fertilizing each hill with three herring. Their survival depended upon a good harvest.

PLYMOUTH NATIONAL WAX MUSEUM
Plymouth, Massachusetts
When the disorderly colony of Wessagusset was threatened by the Indians, Plymouth sent Capt. Standish and twelve men to investigate. Pecksuot, a tall powerful Wessagusset brave, taunted and insulted Standish, who, watching his opportunity, leaped upon the Indian, snatched his knife, and killed him. The threatened massacre was averted.

Pilgrims and Indians, Planting and Reaping, Learning and Teaching

Durant acquired several figures and props from the Plymouth National Wax Museum which have been configured to replicate two scenes originally in the museum. One depicts the English-speaking Indian, Squanto, teaching the Pilgrims to fertilize their corn with fish, ensuring a good harvest in the fall. This scene has served a vital role in the Pilgrim story, acknowledging that without Indian assistance the Pilgrims probably would have perished soon after their arrival. According to the popular story, because of Squanto's help the Pilgrims reaped a bountiful harvest making possible a feast that became the first Thanksgiving. The opposing scene is constructed from a vintage postcard from the wax museum re-enacting a confrontation between Capt. Standish and Pecksuot that led to latter's death. The scene was removed from display in the 1970s because of the violent content, which made Indian–Pilgrim relations perhaps too clear.

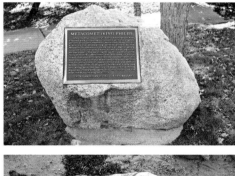

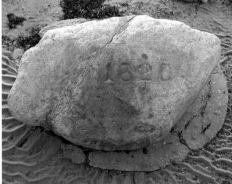

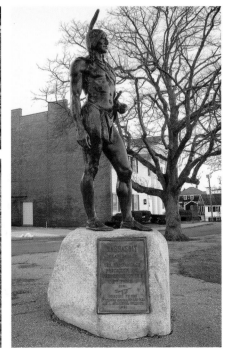

Subject/Position/Object/Placement (Pilgrim Monuments; Massasoit, Metacomet, and Plymouth Rock)

The orientation of the life-size replica of Plymouth Rock and the standing Indian figure refers to the positions of the actual monuments in the town of Plymouth. At the actual site the public stands on the sidewalk looking at the "front" of Plymouth Rock with the harbor opening behind it, standing as the Indians might have, looking toward the oncoming Pilgrims. Cole's Hill rises behind the visitors as they gaze toward Europe. A large bronze statue of the Native American leader, Massasoit, is located on top of the hill. Next to the statue is a small boulder with a plaque describing the "National Day of Mourning." The sculpture of Massasoit also faces the rock, yet he is behind the visitors. Here, Durant places the figure/statue directly into the viewer's field of vision, reversing the situation. Next to the rock and the figure is a sign with text dedicated to Metacomet (called "King Philip" by the Pilgrims) and King Philip's War. The text on this virtually unknown sign is a transcription from the plaque that is located in Plymouth's Post Office Square.

EMILY JACIR

R:

BEYOND

EM
JA

From: "Karin <>
Subject: [arabny] Edward Said to be buried in Lebanon
Date: October 8, 2003 16:07:02 -0400
To: arabny@yahoogroups.com

EMILY JACIR: POETRY'S BEYOND

T.J. DEMOS

In 2006, Emily Jacir shot one thousand books with a .22 caliber gun. Containing only blank white pages, the pierced volumes are displayed as part of *Material for a film (performance)* (2005–06), commissioned by the Biennale of Sydney. The solemnly minimalist installation comprises rows of white shelves that present the books, each inscribed by a single bullet. Part of an ongoing project, *Material for a film* addresses the story of Palestinian intellectual and poet Wael Zuaiter, who returned home to his apartment in Rome on October 16, 1972, only to be gunned down by Israeli assassins in the lobby of his building. One of the bullets hit a copy of *A Thousand and One Nights* that Zuaiter was carrying, as he had been working on an Italian translation of the Arabic original. Mistakenly caught in the blowback from the deadly kidnapping of Israeli athletes by Palestinian militants at the Munich Olympics earlier in 1972, Zuaiter's was a life cut short. Jacir's Sydney piece includes photographs of each perforated page.

Shooting those thousand books (counting Zuaiter's original, there are a thousand and one), Jacir replays the circumstances of Zuaiter's death. But *Material for a film* is a melancholy commemoration as much as a traumatic repetition. The installation defines a powerful image of absence, and thus memorializes a life measured by the incompletion of its projects; in Zuaiter's case, this incomplete project was a literary passion. Jacir presents us with reams of empty pages; Zuaiter's ambition had been to fill them with poetry. "It is a memorial to untold stories," Jacir has explained. "To that which has not been translated. To stories that will never be written." [1]

Material for a film exemplifies Jacir's ambition to express her relation to the recent travails of Palestinians living under occupation and in diaspora, which she does via conceptualist strategies presented in a variety of mediums. Roving over photography and video, painting and sculpture, Jacir's heterogeneous practice parallels the dispersion of Palestinian life. For an artist raised in Saudi Arabia, Europe, and the United States, and now dividing her time between Ramallah and New York, art builds bridges to the lives of others in similar circumstances; it also personalizes tragedy and provides meaningful form for the senselessness of violence.

Crossing Surda (a record of going to and from work), 2002. Two-channel video installation with monitor and projection, color, sound, 132 minutes; and wall text.

Ramallah / New York,
2004–05. Two-channel
video projection with color
and sound, 38 minutes.

FACING PAGE:

*Memorial to 418 Palestinian
Villages which were
Destroyed, Depopulated,
and Occupied by Israel in
1948*, 2000. Refugee tent,
embroidery thread, daily
log of names of people who
worked on tent, 2.4 x 3.6 x
3 m. National Museum
of Contemporary Art,
Athens, Greece

Jacir advanced *Material for a film* at the
2007 Venice Biennale, contributing a presen-
tation of documents and stories of and about
Zuaiter. Jacir found the impetus for her proj-
ect in *For a Palestinian: A Memorial to Wael
Zuaiter*, a book of testimonials from friends
and family put together by his longtime
companion Janet Venn Brown soon after his
death. Italian filmmakers Elio Petri and Ugo
Pirro supplied the chapter "Material for a
film," which contains a series of interviews by
those who knew Zuaiter, but Jacir wished to
go further by assembling photographs of his
neighborhood in Rome and home in Nablus,
videos and audio recordings, documents and
possessions—the result, for her, of years of
research. By spreading those materials over
several rooms, the Venice installation created
a quasi-cinematic presentation, which pro-
posed an audio-visual trajectory for a gradual
experience of Zuaiter's history, slowing
down perception to a commemorative pace.
Making the history of Zuaiter's life present,
Jacir contests his ephemeral existence and
untimely death.

Mahmoud Darwish, the celebrated Pales-
tinian poet, has written: "a people without
poetry is a defeated people."[2] The implica-
tion is that poetry aids survival, rendering
existence significant in circumstances that
defy logical explanation. Darwish's reasoning
recovers the ancient sense of *poesis*—refer-
ring to the art of *making*—once key to the

political formation of community and to
individual well-being, in which life is only
made meaningful when given meaningful
form. Poets, moreover, register injustice
through non-violent means, contesting bru-
tality without perpetuating its hostile cycle.
In agreement with this argument, Jacir notes
in relation to Zuaiter that poets are conse-
quently often regarded by their adversaries
as more dangerous than terrorists.

Intriguingly, Jacir's work also signals an
uneasy relationship to poetry, especially
in view of its compensatory function. "If all
we have left of ourselves are stories, then
in some ways we are already dead," she
explains. For example, "In *A Thousand and
One Nights*, [a thousand-year-old collection
of Middle Eastern–stories which relay the
legend of the wily and beautiful Sheherazade,
whose suspenseful nightly tales saved her
from the deadly fate of her husband's previ-
ous wives] Sheherazade is constantly telling
stories to survive. My reaction to that was
in some ways a refusal of this compulsion to
narrate," says Jacir. Even while commemorat-
ing Zuaiter's story, the empty pages of Jacir's
books and the blankness of her installation's
white walls acknowledge the irrecoverable
nature of the significance of his life, as much
as its unfulfilled potential. That Jacir refuses
to narrate also means that visitors must
become their own storytellers in relation
to the presented material, doing so without

From: "Karin <>
Subject: [arabny] Edward Said to be buried in Lebanon
Date: October 8, 2003 16:07:02 -0400
To: arabny@yahoogroups.com

recourse to dogmatic direction. Jacir's poetic commemoration, far from an authoritative documentary presentation, engenders creative possibilities, at once politically engaging and life affirming.

Courageously—and seemingly against all odds—Jacir has not allowed this sensitivity regarding the inadequacy of art in the face of political crisis to turn into debilitating cynicism. Her earlier work has insistently carved out space for critical contemplation—and at times even room for creative play—in the face of experiential duress. In several projects, for instance, she has addressed her personal experiences with the borders and checkpoints that severely restrict mobility for Palestinians. For the two-channel video, *Crossing Surda (a record of going to and from work)* (2002), Jacir discretely hid a camera in her bag while she walked through a recently installed checkpoint between Ramallah and Birzeit University. Glimpsing signs of the militarized security zone enforced by Israel's occupation forces, the video shows how what was once an everyday commute has transformed into a burdensome and oppressive two-kilometer walk, even for children and the elderly.

That sense of fractured geography contrasts with *from Texas with Love* (2002), for which Jacir recorded the view ahead of her as she drove a car down a highway in Texas for an hour without stopping. Asking fifty-one Palestinians what music they would want to listen to on such an uninterrupted journey were they able to make it, Jacir assembled the artwork's soundtrack with their responses, which included Jimi Hendrix's "Freedom" and Frank Sinatra's "Fly Me to the Moon," as well as Arab nationalist hymns. Meanwhile, *Ramallah / New York* (2004–05) juxtaposes fixed-frame shots of travel agencies, hair salons, shwarma shops, and arghile bars in both cities. The similarity of the establishments (it's nearly impossible to locate the images) suggests that not only

has Palestinian quotidian life spread beyond the Middle East, but also that the second "intifada" (begun in 2000) hasn't impeded a certain normality in the West Bank. It is the perversity of normality situated in the midst of war that Jacir's video exposes, doing so with poignancy and without sentimentality.

Perhaps the most direct of Jacir's commemorative projects is *Memorial to 418 Villages which were Destroyed, Depopulated, and Occupied by Israel in 1948* (2001). It consists of a refugee tent embroidered with these particular villages' names, and recalls a catastrophic episode for Palestinians coincident with the celebrated creation of the state of Israel. Aided by friends and supporters who assisted with the handiwork, the making of Jacir's sculpture represented an act of remembrance, evoking events that, owing to political conflict, are often unacknowledged in the West. During the embroidery sessions, participants read form Walid Khalidi's book *All That Remains: The Palestinian Villages Occupied and Depopulated by Israel in 1948* (1992), grounding historical consciousness in both social bonding and physical process. Jacir similarly utilizes the handmade in order to document tragedy in *Inbox* (2004–05), but here the focus is on recent events, including

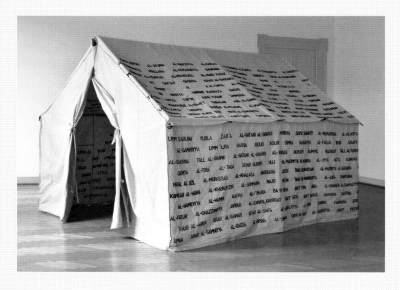

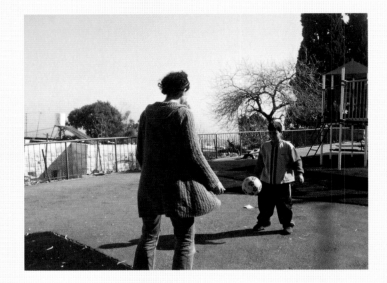

Where We Come From (Hana), 2001–03.
Framed laser print and
C-print mounted on Sintra
Text: 24 x 29 cm; photo:
38.1 x 50.8 cm. Courtesy
the artist and Alexander
and Bonin, New York.
Originally commissioned
by al-Ma'mal Foundation,
Jerusalem, Palestine

the attacks of September 11, 2001. For this work, Jacir painstakingly painted a selection of e-mails from 1998 to 2005 on small wooden panels. The correspondence from friends, family members, colleagues, and Arab and Israeli news agencies invokes the violence, displacement, and oppressive circumstances affecting Palestinians both in and outside the occupied territories. *Inbox* thus builds bridges between members of a diasporic community, translating ephemeral e-mails into a form of history painting.

In a similar manner, *Where We Come From* (2001–03) develops this positioning of art as a vehicle for social connection. Comprising thirty-two photographs of various sizes and nearly as many framed texts in Arabic and English, the piece documents Jacir carrying out services for Palestinians living inside and outside Palestine who lack the freedom of movement, owing to Israeli restrictions. To initiate the piece, she asked them: "If I could do something for you, anywhere in Palestine, what would it be?" As a U. S. passport holder, Jacir could travel where others could not, and she made use of that privilege to dramatize the non-freedom of other Palestinians, to whom Jacir dedicates the piece. The requests are simple, stretching between the banal and ritualistic: "Go to the Israeli post office in

Jerusalem and pay my phone bill," or "Go to my mother's grave in Jerusalem on her birthday and place flowers and pray." By carrying out their wishes and presenting her gestures in photographs, Jacir generates compassion for these people, eliciting the ridiculous geographical circumstances of the Israeli occupation that prevent them from doing what most others in the world take for granted.[3] As a result viewers gain insight into the human cost of the Israeli-Palestinian conflict. Here, stories testify to a life of longing to be at home, as well as to a place—Palestine—that may not be a nation but is nevertheless a powerful state of belonging for a displaced people. Like Zuaiter's poetry, Jacir's art gives those lives meaning; it glimpses survival— and sometimes death—beyond poetry.

1. Emily Jacir, "All That Remains: Emily Jacir," interviewed by Murtaza Vali, *ArtAsiaPacific* (July–August 2007), pp. 98–103. This and all subsequent quotations by Jacir are from this interview.

2. As Darwish explains when he is interviewed in Jean-Luc Godard's film *Notre Musique* (2004).

3. It is worth mentioning that Jacir could not create this work today. As a U.S. passport holder she has been forbidden from entering Gaza since 2003, and can no longer access certain Palestinian villages and towns in the West Bank.

From: "Karin <>

Subject: [arabny] Edward Said to be buried in Lebanon

Date: October 8, 2003 16:07:02 -0400

To: arabny@yahoogroups.com

Although this is a week old, just in case you missed this....

LEBANON
Edward Said to be buried in Lebanon
Posted Thu, 02 Oct 2003

The Palestinian-American writer and intellectual Edward Said, who died last week in New York of leukemia, will be buried in the mountains of Lebanon, a close friend said on Thursday.

"Edward Said wished to be buried in Arab soil, and had chosen Lebanon" as his final resting ground, Lebanese writer Elias Khoury told AFP.

After cremation in the United States, Said's ashes will be brought to Lebanon at the end of October for internment in the Protestant cemetery in the village of Broummana, the home of his wife's family located northwest of Beirut.

Born in west Jerusalem in 1935, Said spent his childhood in Cairo and later settled in the United States. But he often vacationed with his family in the Lebanese mountain village of Dhour Choueir. During the 1960s, he spent a year in Lebanon to further his studies of Arab culture and the Arabic language.

After the Israelis ended their two-decade occupation of Southern Lebanon, Said-known as a tireless defender of the Palestinian cause-returned to the Lebanese-Israeli border in 2001 where he threw a symbolic rock into Israel.

A public ceremony in memory of the writer is being planned in Beirut, said Khoury, one of its organisers and editor of the cultural section of the newspaper, An Nahar, which has produced a special tribute to the author.

AFP

Get McAfee virus scanning and cleaning of incoming attachments. Get Hotmail Extra Storage
http://join.msn.com/?PPAGE=Features/es

Yahoo! Groups Sponsor

Stop Counting Sheep and Get a Better Nights Sleep!
STOP SNORING!
CNN News: SNORING, FATIGUE, APNEA and ADHD Related?" Yes' say Doctors...

%-%

ARABNY Disclaimer:

All information, data, text, software, music, sound, photographs, graphics, video, messages and other materials (&quot;Content&quot), wether publicly posted or privately transmitted are the sole responsibility of the person from which such Content originated. Neither Arabny nor Yahoo controls the Content posted via the Service as such, neither group guarantees the accuracy, integrity or quality of such Content.

October 04, 2003 18:00 hours

among many other strange curiosities is this town's obsession with webcams.
that's me in the front of the fountain standing alone.

October 05, 2003 18:00 hours

in front of the fountain. sitting down. it rained all day.

October 07, 2003 18:00 hours

me with the white umbrella in front of the fountain.
i couldn't make it yesterday because i was in vienna...

October 11, 2003 18:00 hours

me curled up into a ball hiding

October 12, 2003 18:00 hours

me lying on the fountain, staring up at the patch of blue sky above linz, watching a small
white airplane go by

October 13, 2003 18:00 hours

walking on the edge with no jacket! my first sunny day in linz. an old joan armatrading c.d.
in my hand which i bought for cheap on the street. it reminds me of a time in 1991 in texas.
i was worried the photo would click when i was lined up exactly behind the centerpiece.

October 17, 2003 18:00 hours

leaning to the side

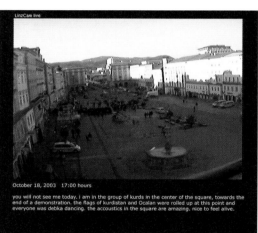

October 18, 2003 17:00 hours

you will not see me today. i am in the group of kurds in the center of the square, towards the
end of a demonstration. the flags of kurdistan and Ocalan were rolled up at this point and
everyone was debka dancing. the accoustics in the square are amazing. nice to feel alive.

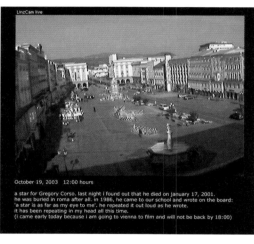

October 19, 2003 12:00 hours

a star for Gregory Corso. last night i found out that he died on january 17, 2001.
he was buried in roma after all. in 1986, he came to our school and wrote on the board:
'a star is as far as my eye to me'. he repeated it out loud as he wrote.
it has been repeating in my head all this time.
(i came early today because i am going to vienna to film and will not be back by 18:00)

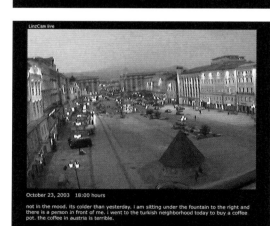

October 23, 2003 18:00 hours

not in the mood. its colder than yesterday. i am sitting under the fountain to the right and
there is a person in front of me. i went to the turkish neighborhood today to buy a coffee
pot. the coffee in austria is terrible.

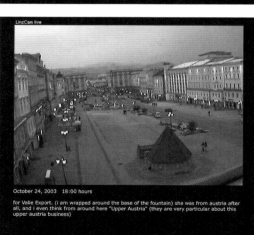

October 24, 2003 18:00 hours

for Valie Export. (i am wrapped around the base of the fountain) she was from austria after
all, and i even think from around here "Upper Austria" (they are very particular about this
upper austria business)

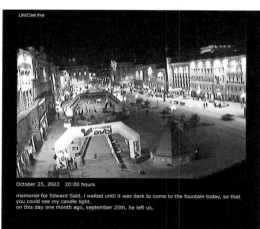

October 25, 2003 20:00 hours

memorial for Edward Said. i waited until it was dark to come to the fountain today, so that
you could see my candle light.
on this day one month ago, september 25th, he left us.

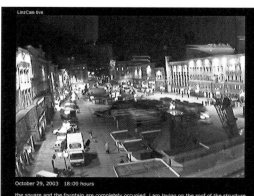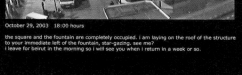

October 29, 2003 18:00 hours

the square and the fountain are completely occupied. i am laying on the roof of the structure
to your immediate left of the fountain, star-gazing. see me?
i leave for beirut in the morning so i will see you when i return in a week or so.

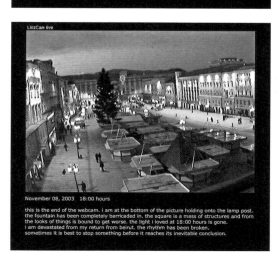

November 08, 2003 18:00 hours

this is the end of the webcam. i am at the bottom of the picture holding onto the lamp post.
the fountain has been completely barricaded in. the square is a mess of structures and from
the looks of things is bound to get worse. the light i loved at 18:00 hours is gone.
i am devastated from my return from beirut. the rhythm has been broken.
sometimes it is best to stop something before it reaches its inevitable conclusion.

LinzCam live

October 08, 2003 18:00 hours

i am with my white umbrella behind the fountain, sick with flu.

LinzCam live

October 09, 2003 18:00 hours

my closed white umbrella and me sitting to your right under the fountain.
it started raining again right after this picture was taken.

LinzCam live

October 10, 2003 18:00 hours

sitting on the edge lined up with the centerpiece

LinzCam live

October 14, 2003 18:00 hours

standing perfectly still. disenchanted. on the left. a boring day in linz.

LinzCam live

October 15, 2003 18:00 hours

curved like a dark moon leaning on the left side of the fountain.
today was a beautiful and sunny day.

LinzCam live

October 16, 2003 18:00 hours

standing on the other side to your right with a white bag in my hand. i am never on that side.
i feel uncomfortable and i don't like that side, so i thought i should make myself stand there.
did you notice that they are digging up the square?

LinzCam live

October 20, 2003 18:00 hours

walking in the fountain. a gloomy day in linz and the clouds are low. it seemed fitting that
when i arrived at the fountain it was empty. no more water.

LinzCam live

October 21, 2003 18:00 hours

my beloved fountain!! look what they did!

LinzCam live

October 22, 2003 18:00 hours

aligned with the fountain's winter cap. it's very cold today and what's the point of the UN
General Assembly wasting their time and hours discussing matters so that they can pass
their resolutions which change nothing, do nothing and mean nothing? no countries are
fooling us just because they vote for a resolution which they know damn well won't actually
do anything. we know they have the power to do something if they wanted and they are
choosing not to. no one can say they didn't know.

LinzCam live

October 26, 2003 18:00 hours

me, my shadow, and an iranian guy who tried to pick me up after this photo was taken.
he is in the white pants walking toward the fountain in the middle of the picture.
i was surprised and confused to see the square so dark at this hour. i had not realized there
was a time change as my computer changed the time automatically.

LinzCam live

October 27, 2003 18:00 hours

a dead beast in the middle of the square. i quite like the way the christmas tree is laying
in the square like a dead dinosaur. on my way to the fountain today i saw the first santa
claus statue up in linz. that's me preparing my camera to take a picture of the dark tree.
ramadan mubarak!

LinzCam live

October 28, 2003 18:00 hours

i am a tree. i stole part of the beast.

That thou canst
Without trou

تحرك زهرة

عج نجما

Che tu non puo
Senza disturb

not stir a flower
bling of a star

لا تستطيع أ
دون أن ت

agitare un fiore
are una stella

المجلد الثاني

ألف ليلة وليلة

ذات الحوادث العجيبة. والقصص المطربة الغريبة لما لها غرام ونفائس

وهيام وحكايات ونوادر فكاهية. ولطائف وطرائف أدبية

والصور المدهشة البديعة من أبدع ما كان ومناظر مجمرة من عجائب الزمان

تطلب من مكتبة ومطبعة محمد علي صبيح

ميدان الأزهر بمصر

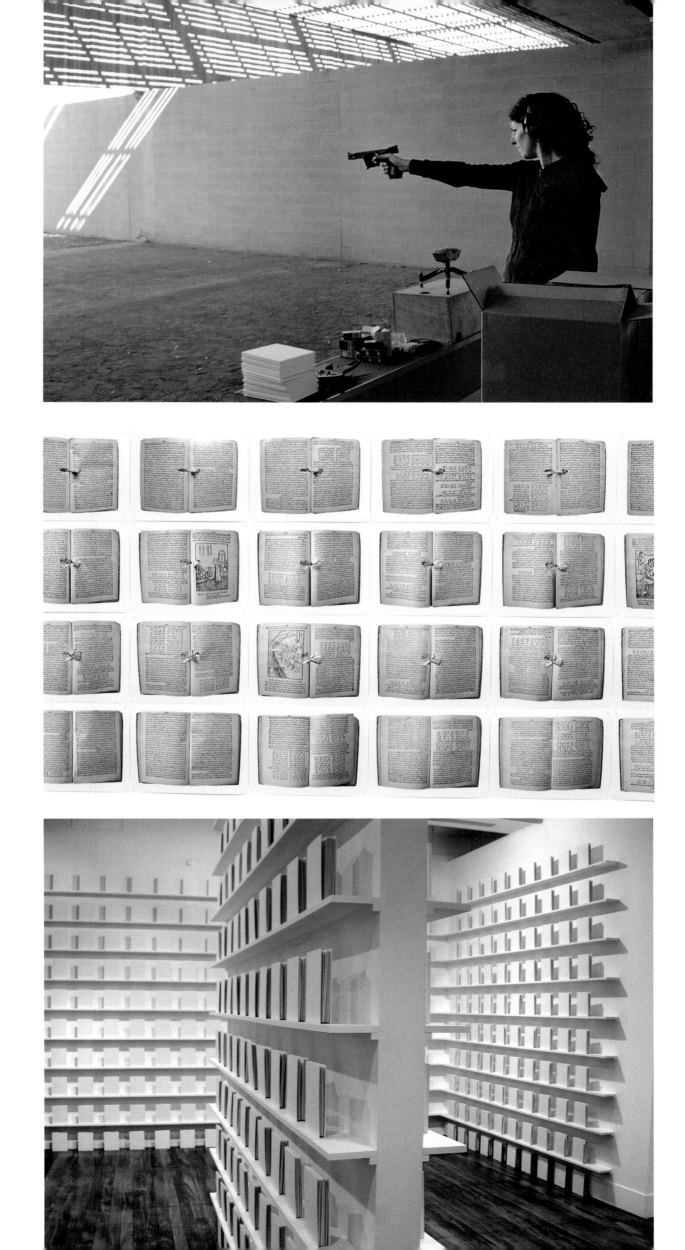

JOACHIM
KOESTEI

BLE

HINGS

JO
KC

THE INVISIBLE INDEX OF THINGS

LARS BANG LARSEN

The logic of expansion always lies at a limit. In modernity, this limit was seen as the light of reason making inroads through the darkness of superstition and the unconscious, and a myth of progress materialized that subjugated nature as well as "lesser" cultures. The occidental world perceived itself as dominating the territories of its various others, rendering governed and transparent what had been unruly and unknown. Bringing this logic of expansion to a standstill, the art of Joachim Koester reevaluates its historical outcomes by probing these liminal conditions of culture.

In Koester's own words, contemporary everyday life is *an invisible index of things*, a reservoir of familiarity that trickles down through history and makes the world an archive of previous constructions of reality.[1] As we know, the victors write History by reproducing cultural affiliations instrumentally and canonically, while other constructions of reality are filtered away or made implausible. It is the latter, powerless and cast-off realities that Koester "ghost-hunts" for subjects. A raconteur, Koester weaves storylines together from a few nodal points, usually accompanied by his own texts. His particular kind of documentary—or meta-documentary—brings dormant events from the past into the present.

In investigations of the media that produce events, Koester often focuses on technolo-

gies of seeing that were used to organize or subjugate the world. But he approaches technologies in instances when they have engendered unintended results, and hence have become self-reflexive. The installation *Message from Andrée* (2005) tells the story of the Swedish engineer S.A. Andrée, who set out to circumnavigate the North Pole in an air balloon, a technological marvel. With his crew of two, Andrée took off from northern Norway in 1897 and was never seen again. Thirty-three years later, the remains of the expedition were found on White Island, together with a stereoscopic camera and a box of negatives—photographs taken by the

The Magic Mirror of John Dee, 2006. Selenium-toned gelatin-silver print, 60.3 x 47.5 cm.

73

explorers that had eroded in arctic incubation. As Koester explains, "While some of the photographs depicted scenes after the landing and the following struggle on the ice, others were almost abstract, filled with black stains, scratches, and streaks of light."[2] The installation's central piece is a 16mm film (3 minutes, 30 seconds) made from these photographs: an animation of a flicker of stains. Historians studying the expedition have tried to see through this visual noise to establish what the explorers saw, but for Koester—employing a structuralist skepticism towards traditional narrative form—the stains, scratches, and streaks of light become Andrée's "message": an opaque manifestation of the failed expedition that renders the experience in a new vocabulary, a code to be deciphered.

The photograph *The Magic Mirror of John Dee* (2006) concerns cartography of a different order. Not himself blessed with the gift of second sight, the English scientist John Dee hired a necromancer, Edward Kelley, to provide him with images from other worlds. In trance, Kelley made contact with demons and angels who spoke of a lost language called Enochian. The black mirror and crystal ball used by Dee and Kelley half a millennium ago, during the seven years of séances it took them to transcribe Enochian, now sit

in a glass case in the British Museum. "Here," writes Koester, "the imperial architecture of the museum is reflected in miniature by the crystal ball, while the visitor's gaze is greeted by a dark absence when it encounters the mirror. A blank surface that, although mute, seems to emanate a narrative persistence not unlike a photograph."[3] Indeed, there has always been something metaphysically suggestive about new media. Apart from its blurry mirroring of the built space surrounding it, Koester's close-up photograph of the magic mirror shows minute scratches that worm across its surface, evoking the starry night of a new cosmos. Both *Message from Andrée* and *The Magic Mirror of John Dee* imply ways of seeing that do not rely solely on the eyes; they are works that give the beholder much space for individual interpretation. With Gilles Deleuze, we could call this free space for art's "celestial state": When art does not find correspondence in the available interpretive maps, it goes beyond the personal and the rational to suggest routes in actual as well as imaginary worlds.[4] This focus on the invention of meaning, rather than the explanation or interpretation of meaning, recurs in other speculative cartographies of the sensorial, such as Koester's 16mm animation of the psychedelic Lettrist Henri Michaux's mescaline drawings (*My Frontier is an Endless Wall of Points* [2007]).

In *Morning of the Magicians* (2005), we are confronted with, among other things, nightmarish, phantasmagorical wall paintings at the Abbey of Thelema, the Sicilian retreat where the post-Victorian occultist Aleister Crowley kept state with bacchanals and drug-fueled initiation rites in the 1920s. Following filmmaker Kenneth Anger and sex and gender researcher Alfred C. Kinsey's discovery of the abandoned temple in 1955, Koester's unlikely rediscovery of the once more forgotten and now ruinous abbey adds to its history as a clandestine site that thus seems predestined to wallow in a series of disappearances and reappearances. If a site or a city is not

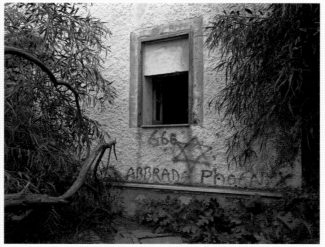

only a social reality, made up of the facts of its architecture and infrastructure, but also a state of mind, it follows that the space can be re-actualized through its imagined history. The photography sequence *The Kant Walks* (2003–04) documents the route of Immanuel Kant's daily constitutional in his hometown, Königsberg (then a Prussian city), which was razed by air raids in World War II and renamed Kaliningrad. It subsequently became a militarized Russian enclave that underwent a post-Soviet economic slump and is now picking up as "the Baltic Las Vegas."[5] Using Kant's walks as a script for seven photographs, Koester implicitly juxtaposes the philosopher's idealist systems with walking as a subjective, concrete approach to history: a drift where one can find or lose oneself and that "evokes history as a chaos, a dormant presence with far more potential than tidy linear narratives used to explain past events."[6] In Walter Benjamin's term, *Morning of the Magicians* and *The Kant Walks* depict prophetic corners: actual places from which we can trace past lines of development and extrapolate them in the direction of future events, making everything that lies ahead of us seem like a past.[7]

In the recent film *Tarantism* (2008), six dancers improvise silently and spasmodically.

Reminiscent of choreographic experiments of the 1960s and '70s and the way they were documented, Koester's anthropological camera registers the dancers who quiver and gyrate in the background of an empty space, yet break off their outbursts of seemingly uncontrollable energy as if on cue. In southern Italy, legend had it that only frenzied dancing would neutralize the convulsions resulting from a bite by the Tarantula spider. However it is more likely that the so-called Tarantella dance—practiced up until the mid-twentieth century, often by women—was a pretext to subvert repressive policies of the church. The clerics themselves suspected as much, but when the Bishop of Polignano in the seventeenth century let himself be bitten by a Tarantula to disprove the need for the dancing cure, he, too, let it all hang out in a frenzied dance of his own to relieve his symptoms.

Like Koester's *Pit Music* (1996), a staging of a string quartet that performs a piece by Dmitri Shostakovich in an art gallery, *Tarantism* is a filmed performance that re-introduces the body in his work, as does the subject of the occult, with its quasi-erotic heightening of the senses. In his docu-fictional account of the great epidemic in seventeenth-century London, *A Journal of*

FACING PAGE:
My Frontier is an Endless Wall of Points, 2007. 16 mm black-and-white film, 10 minutes, 24 seconds.

ABOVE LEFT:
The Room of Nightmares #2, 2005. C-print, 47.5 x 60.3 cm.

ABOVE RIGHT:
The Abbey of Thelema #4, 2005. Selenium-toned gelatin-silver print, 47.5 x 60.3 cm.

the Plague Year (1722), Daniel Defoe writes about a man who leaves his sickbed, and "by the insufferable torment he bore, danced and sung naked in the street, not knowing one ecstasy from another."[8] Defoe here brilliantly captures ecstasy's dark ambivalence: it can be a revelation or a dance of death, and it is a thin line between them. Defoe's descriptions of people dying in the street resonates with the dancers' performances in *Tarantism*, not least because he reads the antic gestures of the dying as signs: "It is impossible to describe the variety of postures in which the passions of the poor people would express themselves."[9] However, even if ecstasy is indeed always inscribed in an expressive or representational logic, attempts to give it a political direction have proven fatal; just think of twentieth-century totalitarian mass movements, or the ideological deserts that, in some cases, followed in the wake of the 1960s' utopian fusion of pleasure and politics. As Koester's dancers show us, however, ecstasy's extreme, affective connections between mind and body always harbor the promise of a difficult freedom—a promise that abides, perhaps, precisely because ecstasy is ultimately unruly.

Koester's meta-documentaries, with their peregrinations through invisible indexes of the visible world, make for a politics of inspiration that places the viewer in the middle of potentials hidden in time. Documentary's promise of indexical representation of reality is destabilized when it is applied simultaneously to opposed domains (language and nonlanguage, past and future, seen and unseen), and Koester's focus on uncharted sites outside of fact challenges the genre's capacity to locate concrete, knowable things. In Koester's projects, a culture's secrets, and its unease, become lines of flight that reverberate critically within conventional histories. With a strange optimism, his works revolve around events where everything could have—or perhaps already have—taken a different turn.

1. Joachim Koester, *Joachim Koester. Message from the Unseen* (Malmö: Lund Konsthall and Veenman Publishers, 2006), p. 37.

2. Ibid., p. 89.

3. Ibid., p. 145.

4. Gilles Deleuze, "Ce que les enfants dissent," in *Critique et clinique* (Paris: Minuit, 1993), p. 86.

5. http://business.timesonline.co.uk/tol/business/specials/russias_regions/article3074628.ece.

6. Koester, pp.123–24.

7. Walter Benjamin, *Berlin Childhood Around 1900* (Cambridge, Mass.: Belknap Press, Harvard University, 2006).

8. Daniel Defoe, *A Journal of the Plague Year* (1722; London: Dover Thrift Editions, 2001), p.133.

9. Ibid., p. 61.

The Kant Walks #1, 2005.
C-print, 47.5 x 60.3 cm.

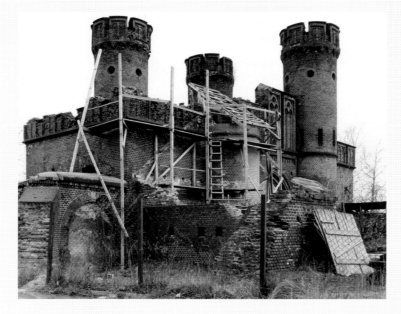

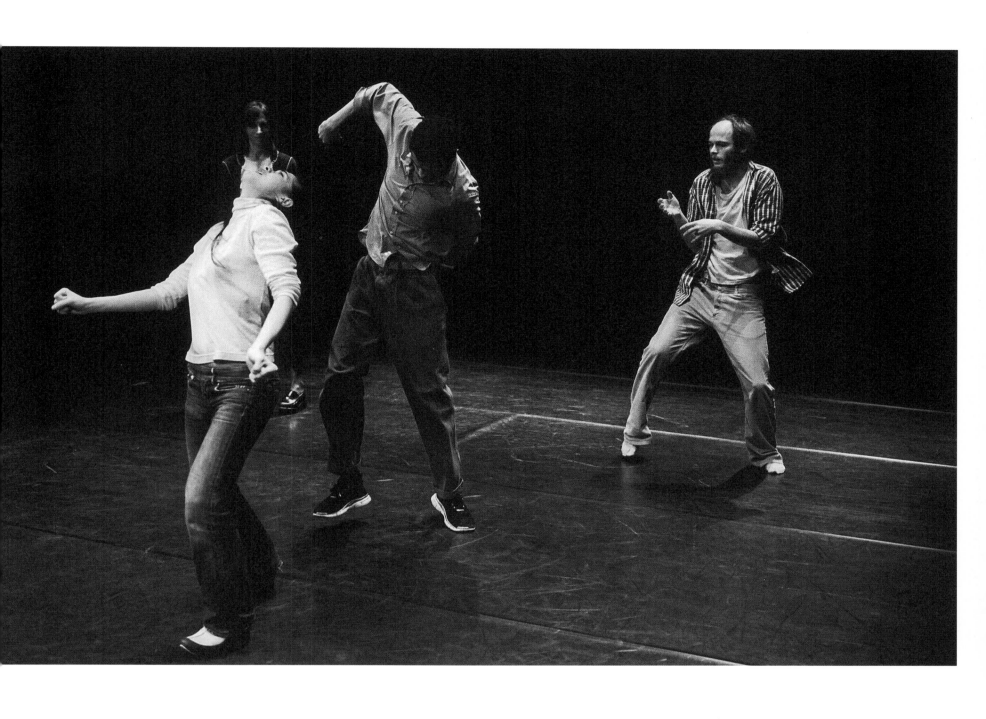

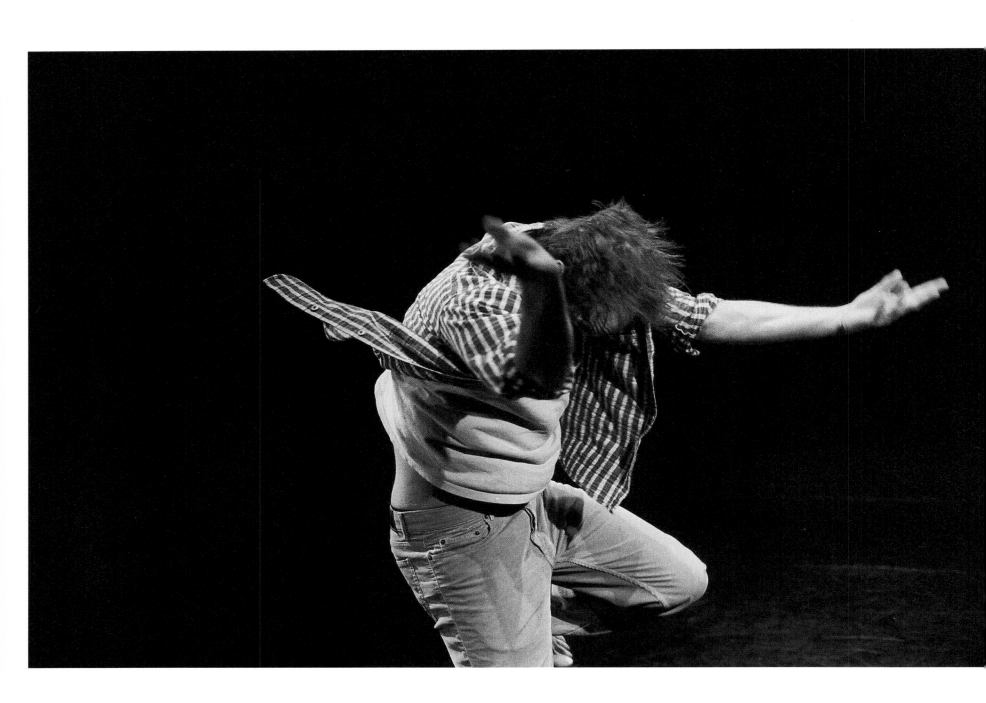

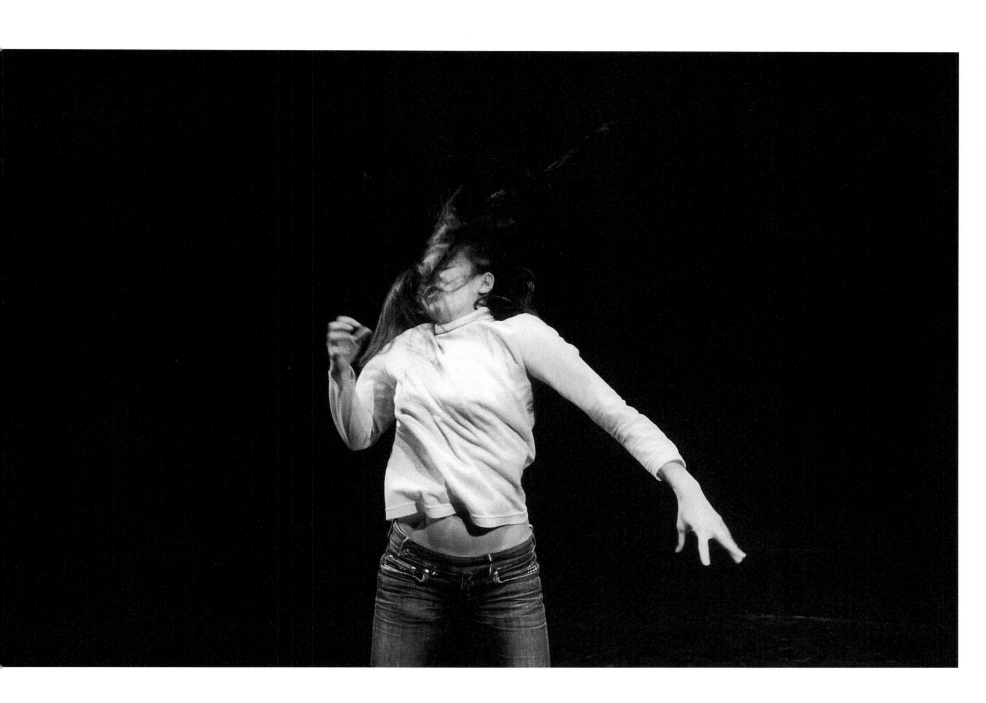

EXPÉDITION POLAIRE ANDRÉE, 1897.

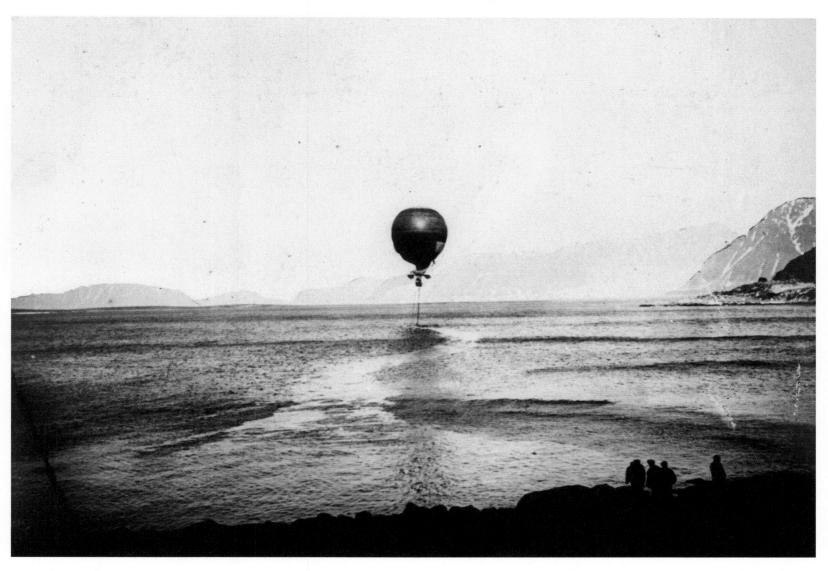

CLICHÉ ALEXIS MACHURON.

OBTENU ET AGRANDI AVEC JUMELLE PHOTOGR. MACKENSTEIN.

Départ du Ballon Andrée. (11 Juillet.)

ROMAN SIGNER

GNER:

**RO
SIC**

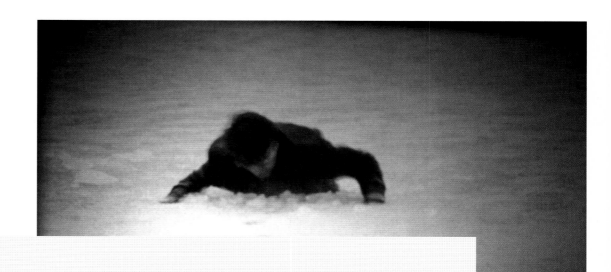

ROMAN SIGNER: SIGNS FOR OUR TIMES

GERHARD MACK

In a highly idiosyncratic way, Swiss artist Roman Signer expands the notion of sculpture—a genre often popularly thought of as stationary and representational—by adding an element of time to his work. Signer's sculptures mesh the permanence of the captured moment into the temporal continuum, into a process of creation and transformation. In his work, Signer sets up an initial situation, replete with some sort of potential energy that is then released, often altering the preexisting material. Here it is the whole process, not simply the result that constitutes the sculpture.

All of this—the simple, craftsman-like materials, the performance elements, and the almost humble interaction with nature—is rooted in the art of the sixties and seventies. Signer's first introduction to prominent examples of a more expansive concept of art was the 1969 exhibition *Live in Your Head: When Attitudes Become Form*, curated by Harald Szeemann at the Kunsthalle Bern. However, Signer's approach to his art also has precedents in Marcel Duchamp's investigations of methods of perception. Based on these antecedents, Signer has developed an idiom uniquely his own. Simple elements, predominantly water and sand, compose his basic materials, and natural forces—at times silent and slow, (like the gravity that stretches the rubber bands attached to steel weights) and at other times deafening (like the shots and explosions that reference

natural thunder)—provide creative energy. With these materials and forces, Signer often creates initial situations in such a way that they can produce their effects without further intervention.

Working with time, making out of it a material to be given three-dimensional form, means emphasizing its modalities. When, at the Venice Biennale, Signer had all the cords on which blue steel balls were hanging severed at the same moment by a detonating system, the balls fell to the floor together, or with slight delays, illustrating the difference between simultaneity as a physical concept and its realization (*Simultaneous* [*Gleichzeitig*, 1999]). And when, for his work *Action with a Fuse* (*Aktion mit einer Zündschnur*, 1989) the artist laid burning fuses over a 20.6 kilometer stretch of railroad track, coupling them together every 100 meters, he partitioned space-time into an almost modular sequence: intermittent explosions occurred as one fuse segment ran its course and lit the next over a continual period of thirty-five days.

The way an activity unfolds in space and time, the discrepancy between our anticipation of an event and our memory of its specific outcome, is a crucial feature of our narrative relationship to the world. Roman Signer's works articulate this distinct narrative potential. He himself speaks of "events." The candle burning down toward a pillow

filled with gasoline rivets our attention on the moment when the flame will ignite the liquid (*Cushion with Candle* [*Kissen mit Kerze*, 1983]). The Piaggio that rolls down an old ski jump, makes a short leap through the air, and lands in the undergrowth, enunciates a course of events in space-time and captures, like a modern day Icarus, our yearnings for the impossible (*Piaggio on Ski Jump* [*Piaggio auf Schanze*, 2003]). Chance removes the strands of the narrative from the director's hands.

The easy rhythm set up by the artist is often expressed in Signer's work in a musicality all his own. Music is the modulation of time, and in this sense the installations and "events" staged by this son of a music director have the sound of compositions. The work with which he brought Documenta 8 to a close in Kassel in 1987 juxtaposed sound and silence, instant and duration, in the simplest possible way. Three hundred stacks of paper, each containing 1,000 sheets, were blasted into the air by linked explosions (*Action in Front of the Orangerie* [*Aktion vor der Orangerie*, 1987]). There was a single loud bang, then the paper wafted silently back to earth for several minutes. The result was a unique mixture of minimalist linearity and zen-like plenitude expressed by the sheer quantity of sheets of paper and their movement in response to the wind and the force of the explosion. The field, the Karlsaue, was turned into a unique artistic space by the structure of the sound.[1]

The musical structure of his work leaves behind images in the mind of the viewer, and similarly, Signer has himself referred again and again to the visual medium of painting.[2] In his selection of materials and settings for his works he often considers their colors. A ladder with large red balloons squeezed between its rungs is seen leaning against an apple tree with red fruit in a lush green

ABOVE:
Cushion with Candle
(*Kissen mit Kerze*), 1983

FACING PAGE:
Simultaneous (*Gleichzeitig*),
1999. Installation views,
Swiss Pavilion, 48th Venice
Biennale, 1999

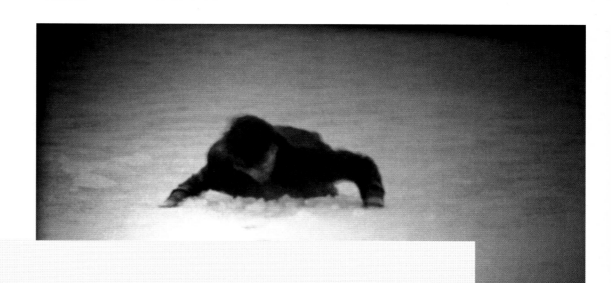

setting (*Ladder with Balloons [Leiter mit Ballonen,* 1994]). Nature provides the colors, but in choosing similar ones for his work, the artist increases the yearning for a fruit laden with biblical connotations, and creates a situation in which it is impossible to reach the desired object without destroying the beautiful and suggestive play of forms on the ladder, and the overall tableau. In his *Barrel (Fässer)* works Signer shoots paint can lids at museum ceilings by means of explosives. Paint becomes a marker that permits a viewer to retrace forces and movements. The potential of sculptural arrangement is employed to apply color and achieve the effect of composition. Yet Signer manages to avoid any hint of personal expression since he sets up his arrangement with the indifference of a laboratory technician. He liberates painting from the dialectic of expressiveness and non-expressiveness inherent in the medium.

The effects of Signer's sculptural approach to art can be seen in his silhouette and video self-portraits. At the 1999 Venice Biennale he had himself shut up in a wooden cabin and sprayed by an exploded bucket of paint, making himself the picture support instead of the traditional subject of a painting (*Cabin [Kabine,* 1999]). The pigment is dispersed and the artist, painting himself, is extinguished by it. He is afterwards only recognizable in the silhouette of his absence in the midst of the splashes on the wood. Painting is employed in both an archaic and highly modern manner to both mark and evoke the body. With something of the immediacy of cave painting, it is a question of the essential basis of depiction, of the necessity of images.

Signer not only engages the visual legacy of painting but also that of drawing. At Kaspar König's *Skulptur. Projekte in Münster* 1997, Signer sank a rod attached to a squirting hose into the stream below, and depending on the current, streams of water were shot into the air, producing a three-dimensional drawing

in time (*Walking Stick [Spazierstock,* 1997]). The two-dimensional medium of drawing was extended into space, and its traditional durability exchanged for the fleeting moment, the temporal dimension of Signer's sculpture. For once drawing—the thoughtful sketch— was not something to which one could revert, with which one could reassure oneself of what had been seen, but rather something characterized by an element of chance. Reminiscent of the sketches of John Cage, Signer's work expanded the latter's evanescent nature even further, into the actual

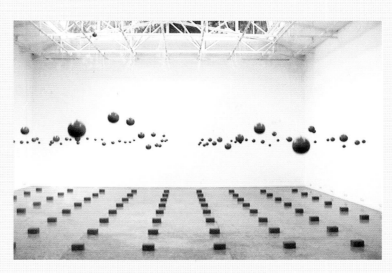

moment. It would be difficult to find a more perfect expression of the lightness of being than the sight of that sputtering, quivering jet of water.

Many works express this, in the end, existential dimension with a blend of menace and comedy. Among these is the helicopter, impossible to control, that is smashed against the walls of a small room by the turbulences it creates itself until it is finally broken to pieces (*Floating in a Box* [*Schweben in einer*

*Ladder with Balloons
(Leiter mit Ballonen)*, 1994

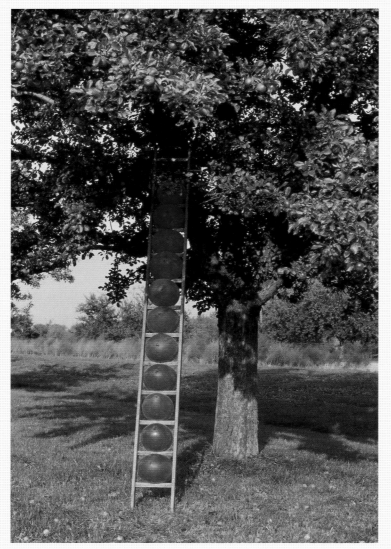

Kiste, 1999]). And then there is the ride in a kayak, in which the artist pulls himself along by means of a rope across a gravel path next to a river, which inadvertently becomes a pathetically humorous race once two grazing cows become frightened and start trotting off *(Kayak* [*Kajak*, 2000]). But then there are calm works like the one in which two electric fans are placed facing each other (*Two Fans* [*Zwei Ventilatoren*, 1999]). One is plugged in, and the air currents it creates turn the blades of the other as well; it is almost as if artificial respiration were responsible for their contrary motion. And finally there is the automobile that Signer raced into the angle formed by a pair of cement barriers in Hamburg. A work that symbolized, like a beetle flailing its legs, what it is like to be in an impossible situation (*Narrow Pass* [*Engpass*, 2000]). There is never any hint of judgment in any of Signer's works. His art is instead characterized by the engaged aloofness of the artist-researcher. No matter how things work out, the real forces he invites to work with him function as equal partners in the situations to the very end. He is committed to an element of reality: When a real truck tipped over and its load of sugar trickled out to form cones on the pavement, the artist saw it as a chance installation, one that could not have been more poetic in its combination of destructive force and newly created form.[3]

1. Other works, like the installation-action for the opening of the Kunstmuseum St. Gallen in Switzerland, took on a complex symphonic dimension (*Actions for the Reopening of Kunstmuseum St. Gallen* [*Aktionen zur Wiedereröffnung des Kunstmuseums St. Gallen*, 1987]).

2. As early as 1973 Signer dissolved yellow and blue food coloring in separated areas of water. He then let the two mingle very slowly until they became one homogeneous green color, thus combining time and color (*Gradual Fusion* [*Langsame Vermischung*, 1973]).

3. Sometime during the late seventies or early eighties, Signer saw such an accident on the motorway.

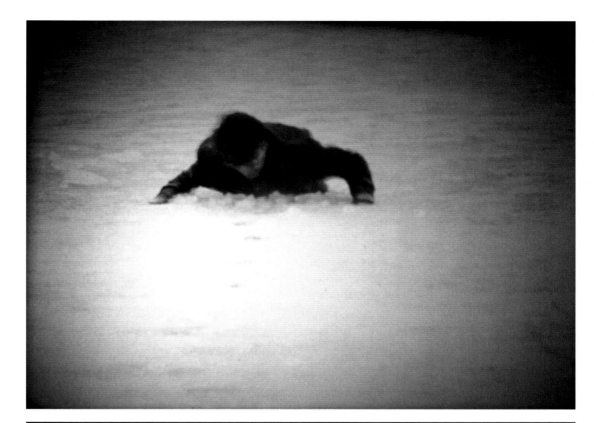

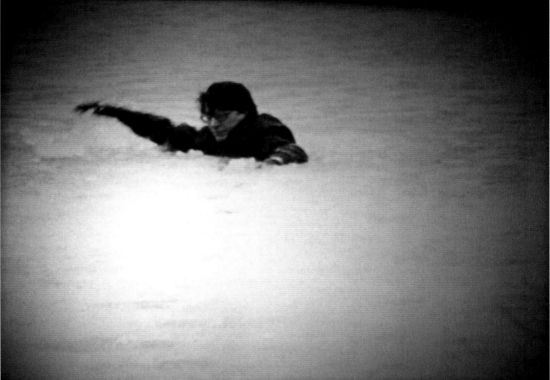

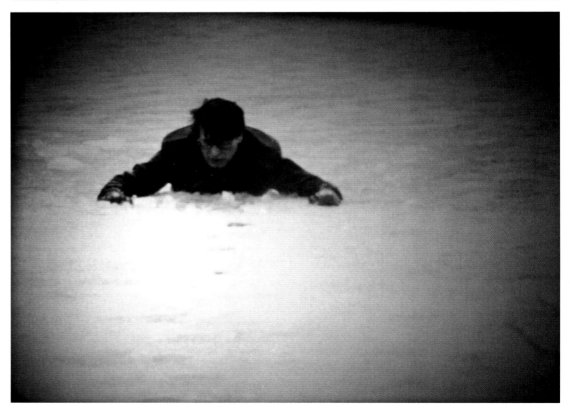

Einbruch in Eis, 1986

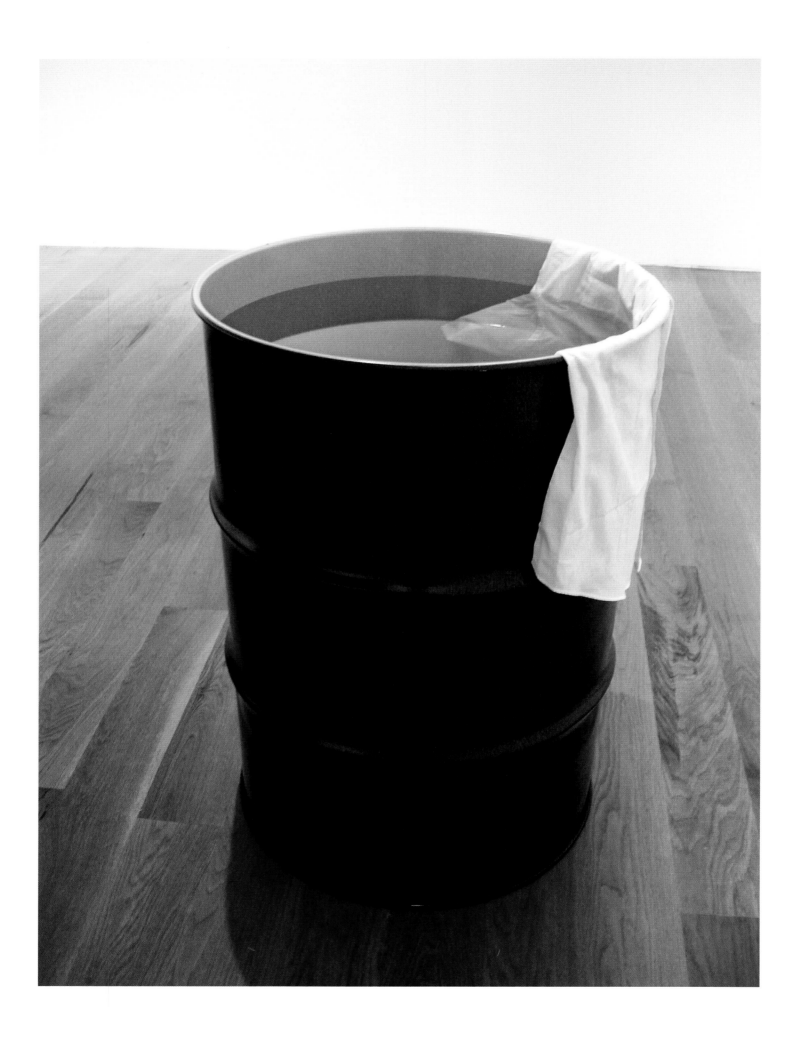

Hemd, 2005

Piaggio auf Schanze, 2003

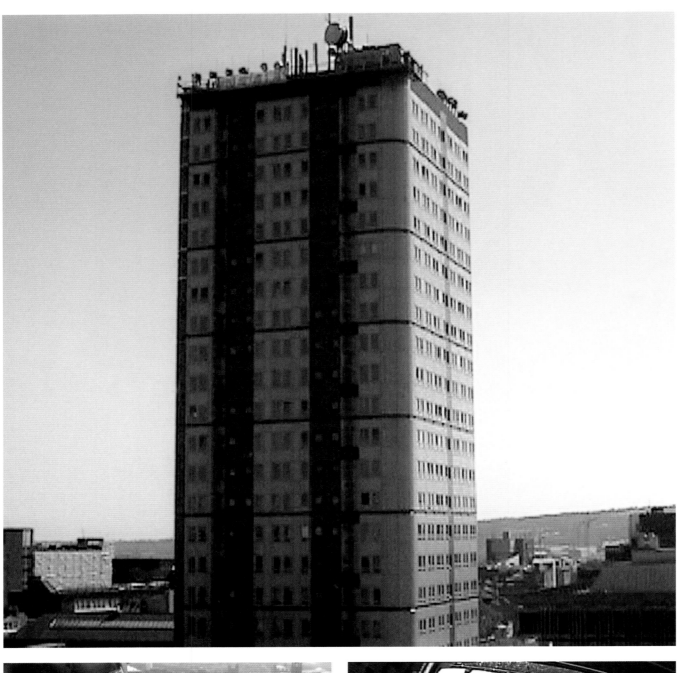

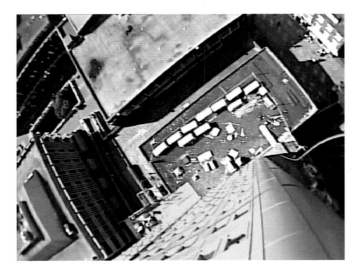

Eimmer mit Kamera, 2002

Engpass, 2000

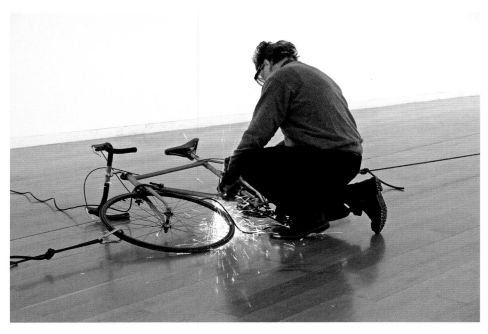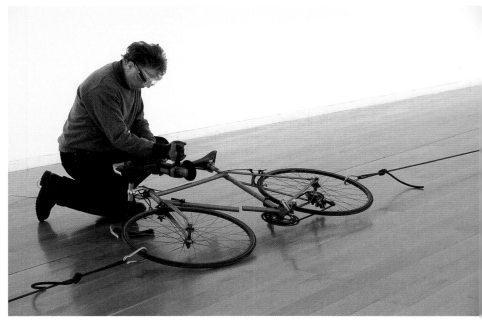

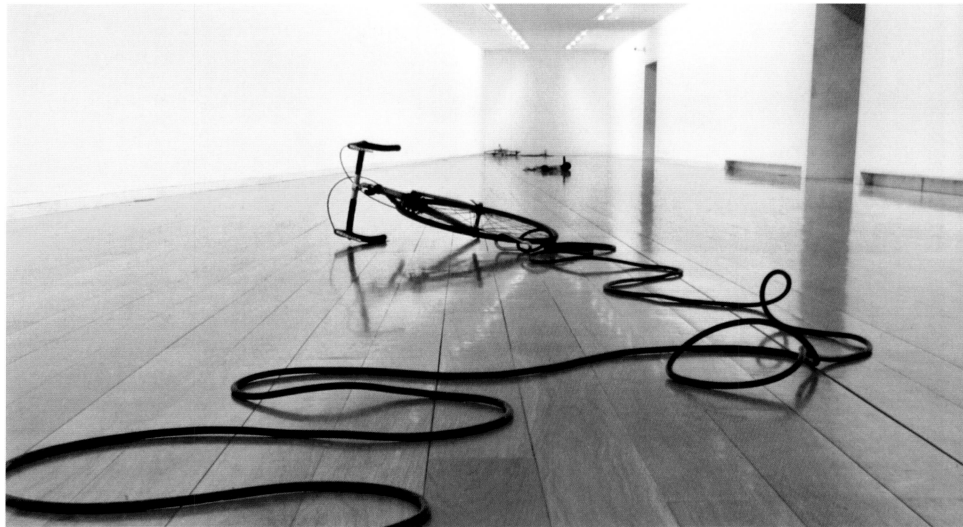

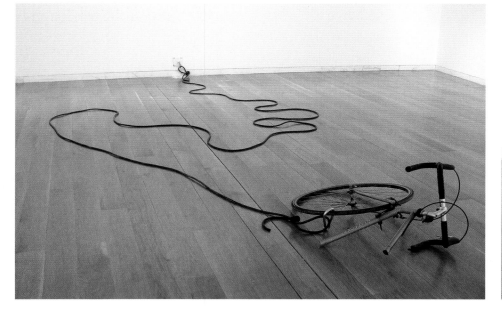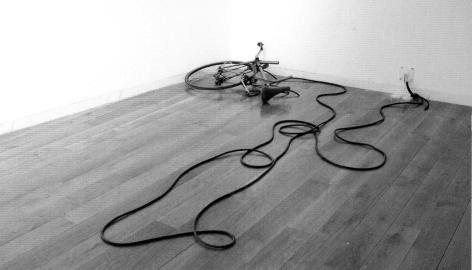

Fahrrad, 2006

Tisch, Island, 1994

APPENDIX

EXHIBITION HISTORIES

PATTY CHANG

BORN 1972 IN SAN LEANDRO, CALIFORNIA
LIVES AND WORKS IN NEW YORK CITY

SELECTED SOLO EXHIBITIONS

2008

Brunswick, Maine, Bowdoin College Museum of Art, *Patty Chang: For Abramovic, Love Cocteau*, Jan. 9–Apr. 13.

2006

Stockholm, Moderna Museet, *Shangri-La—dokument och fiktion*, Aug. 1–27.

Berlin, Arratia, Beer, *Fan Dance*, Mar. 25–May 20.

2005

Manchester, England, Chinese Arts Centre, *Patty Chang*, Oct. 21–Dec. 23.

Los Angeles, Hammer Museum, *Shangri-La*, June 25–Oct. 16. Traveled to New York, New Museum of Contemporary Art, July 8–Sept. 10; Chicago, Museum of Contemporary Art, May 20–Aug. 20, 2006. Catalogue.

2001

Visby, Sweden, Baltic Art Center, *Patty Chang*, June 17–July 31.

Fribourg, Switzerland, Fri-Art Centre d'Art Contemporain, *Patty Chang*, Apr. 8–May 27.

2000

San Francisco, Yerba Buena Center for the Arts, *Let Down and Release*, May 3–July 23.

Madrid, Spain, Museo Nacional Centro de Arte Reina Sofía, *Ven conmigo, nada contigo: Fuente. Melones. Afeitada*, May 27–July 6.

1999

New York, Jack Tilton Gallery, *Patty Chang*, May 23–Apr. 24.

SELECTED GROUP EXHIBITIONS

2008

New York, Film Society of Lincoln Center and the Museum of Modern Art, *New Directors / New Films Series*, Mar. 26–Apr. 6.

North Adams, Massachusetts, Massachusetts Museum of Contemporary Art, *Eastern Standard: Western Artists in China*, Feb. 2, 2008–Feb. 22, 2009.

2007

Berlin, Haus der Kulturen der Welt, *New York: States of Mind*, Aug. 24–Nov. 4. Traveled to New York, Queens Museum of Art, Dec. 16, 2007–Mar. 23, 2008. Catalogue.

New York, Solomon R. Guggenheim Museum, *Family Pictures*, Feb. 9–Apr. 16. Catalogue.

2006

New York, Asia Society, *One Way or Another: Asian American Art Now*, Sept. 7–Dec. 10. Traveled to Houston, Blaffer Gallery, Art Museum of the University of Houston, Jan. 20–Mar. 31, 2007; Berkeley, Berkeley Art Museum, Sept. 19–Dec. 23, 2007. Catalogue.

Santa Fe, Site Santa Fe, Sixth International Biennial, *Still Points of the Turning World*, July 9, 2006–Jan. 7, 2007. Catalogue.

New York, P.S. 1 Contemporary Art Center, *Into Me / Out of Me*, June 25–Sept. 25. Catalogue.

2005

Philadelphia, Institute of Contemporary Art, University of Pennsylvania, *Springtide*, Apr. 30–July 31. Brochure.

2004

Trento, Italy, Galleria Civica di Arte Contemporanea, *Dimensione Follia*, Sept. 25–Jan. 9.

2003

New York, International Center of Photography, *Only Skin Deep: Changing Visions of the American Self*, Dec. 12, 2003–Feb. 29, 2004. Catalogue.

New York, Studio Museum in Harlem, *Black Belt*, Oct. 15, 2003–Jan. 4, 2004. Traveled to Santa Monica Museum of Art, Dec. 11, 2004–Feb. 12, 2005. Catalogue.

Cincinnati, Contemporary Arts Center, *Somewhere Better Than This Place*, Mar. 28–Nov. 29. Catalogue.

2002

New York, Solomon R. Guggenheim Museum, *Moving Pictures*, June 28, 2002–Jan. 12, 2003. Traveled to Guggenheim Museum Bilbao, Oct. 8, 2003–May 18, 2004. Catalogue.

Los Angeles, Hammer Museum, *Mirror Image*, Feb. 9–May 5. Traveled to Annandale-on-Hudson, New York, Center for Curatorial Studies, Bard College, June 23–Sept. 8.

Athens, Deste Foundation Center for Contemporary Art, *Fusion Cuisine*, June 20–Oct. 30. Catalogue.

2001

Ghent, Belgium, Stedelijk Museum voor Actuele Kunst, *CASINO 2001: 1ste Quadriënnale voor Hedendaagse Kunst*, Oct. 28, 2001–Jan. 13, 2002. Catalogue.

2000

Berlin, Kunstlerhaus Bethanien, *Cross Female: Metaphern des Weiblichen in der Kunst der 90er Jahre*, Sept. 29–Oct. 29. Traveled to Pforzheim, Germany, Kunstverein Pforzheim, Apr. 22–May 27, 2001. Catalogue.

1996

New York, Exit Art, *Terra Bomba: A Performance View of Installation*, Dec. 7, 1996–Mar. 8, 1997.

SAM DURANT

BORN 1961 IN SEATTLE, WASHINGTON
LIVES AND WORKS IN LOS ANGELES

SELECTED SOLO AND TWO-PERSON EXHIBITIONS

2008
Paris, Praz-Delavallade, *Sam Durant*, Mar. 15–May 17.

2007
London, Sadie Coles HQ, *Sam Durant*, Nov. 22, 2007–Jan. 19, 2008.

New York, Paula Cooper Gallery, *Sam Durant: Echoplex*, Mar. 31–Apr. 28.

Vancouver, Catriona Jeffries Gallery, *Scenes from the Pilgrim Story: Natural History*, Mar. 16–Apr. 14.

Los Angeles, Blum & Poe, *Scenes from the Pilgrim Story: Myths, Massacres and Monuments*, Mar. 3–Apr. 14.

2006
Boston, Stephen D. Paine Gallery, Massachusetts College of Art and Design, *Scenes from the Pilgrim Story: Myth, Massacres and Monuments*, Nov. 7–Dec. 22. Catalogue.

2004
Ghent, Belgium, Stedelijk Museum voor Actuele Kunst, *Sam Durant: 12 Signs: transposed and illuminated (with various indexes)*, May 8–Sept. 5. Catalogue.

Milan, Galleria Emi Fontana, *We are all Outlaws in the Eyes of America*, May 5–July 30.

2003
Vienna, Secession, *Break it / Fix it* (in collaboration with Monica Bonvicini), Nov. 28, 2003–Feb. 1, 2004. Catalogue.

Houston, Project Row Houses, *We Are the People*, Project Row Houses' Round 19, Oct. 1–31.

New Plymouth, New Zealand, Govett-Brewster Art Gallery, *Sam Durant: Entropy in Reverse*, July 26–Sept. 20. Catalogue.

2002
Los Angeles, Museum of Contemporary Art, *Sam Durant*, Oct. 13, 2002–Feb. 9, 2003. Catalogue.

Milwaukee, Institute of Visual Arts, University of Wisconsin, *Sam Durant*, Sept. 21–Dec. 8.

Hartford, Wadsworth Atheneum Museum of Art, *Matrix 147: 7 Signs: removed, cropped, enlarged and illuminated (plus index)*, May 18–Sept. 1.

Düsseldorf, Germany, Kunstverein für die Rheinlande und Westfalen, *Sam Durant*, Jan. 18–Mar. 30. Catalogue.

2001
Zurich, Kunsthof Zürich, *Consciousness Raising Historical Analysis, Pain Plus Time Separated and Ordered with Emphasis on Reflection*, May 25–June 30.

SELECTED GROUP EXHIBITIONS

2008
Sydney, 2008 Biennale of Sydney, *Revolutions—Forms That Turn*, June 18–Sept. 7. Catalogue.

Houston, Contemporary Arts Museum Houston, *The Old, Weird America*, May 3–July 20. Catalogue.

2007
New York, New Museum, *Unmonumental: The Object in the 21st Century*, Dec. 1, 2007–Mar. 30, 2008. Catalogue.

Detroit, Museum of Contemporary Art, *Words Fail Me*, Sept. 16, 2007–Jan. 20, 2008.

New York, Whitney Museum of American Art, *Resistance Is…*, June 29–Sept. 2.

London, Institute of Contemporary Arts, *Memorial to the Iraq War*, May 23–June 27.

2006
Busan, Korea, *Busan Biennale 2006*, Sept. 16–Nov. 25. Catalogue.

2005
San Francisco, CCA Wattis Institute for Contemporary Arts, *Monuments for the USA*, Apr. 7–May 14. Traveled to New York, White Columns, Dec. 15, 2005–Jan. 28, 2006. Catalogue.

Bergamo, Italy, Galleria D'Arte Moderna e Contemporanea, *WAR IS OVER 60 anni di libertà 1945–2005*, Oct. 15, 2005–Feb. 26, 2006. Catalogue.

Moscow, *1 Moscow Biennale of Contemporary Art*, Jan. 28–Feb. 28. Catalogue.

2004
New York, Whitney Museum of American Art, *Whitney Biennial 2004*, Mar. 11–June 13. Catalogue.

2003
Venice, 50th Venice Biennale, *Dreams and Conflicts: The Dictatorship of the Viewer*, June 15–Nov. 2. Catalogue.

Cincinnati, Contemporary Arts Center, *Somewhere Better Than This Place*, Mar. 28–Nov. 29. Catalogue.

2002
Chicago, Museum of Contemporary Art, *Out of Place: Contemporary Art and the Architectural Uncanny*, June 8–Aug. 11. Traveled to Gainesville, Samuel P. Harn Museum of Art, University of Florida, Sept. 3–Nov. 24. Catalogue.

1999
Los Angeles, Museum of Contemporary Art, *Proliferation*, Mar. 7–June 20.

1998
Aachen, Germany, Suermondt Ludwig Museum, *Entropy at Home*, Aug. 1–Oct. 11.

1997
Los Angeles, Hammer Museum, *Scene of the Crime*, July 23–Oct. 5. Catalogue.

EMILY JACIR

BORN 1970 IN PALESTINE
LIVES AND WORKS IN RAMALLAH, PALESTINE AND NEW YORK

SELECTED SOLO EXHIBITIONS

2007
St. Gallen, Switzerland, Kunstmuseum St. Gallen, *Emily Jacir*, Sept. 1–Nov. 25. Traveled to Esslingen, Villa Merkel, Dec. 16, 2007–Feb. 17, 2008.

Torino, Italy, Alberto Peola Arte Contemporanea, *ENTRY DENIED*, Feb. 9–Mar. 31.

2005
London, Anthony Reynolds Gallery, *Emily Jacir*, June 4–July 9.

New York, Alexander and Bonin, *Emily Jacir: accumulations*, Feb. 26–Apr. 9.

Wichita, Kansas, Ulrich Museum of Art, *Ulrich Project Series: Emily Jacir*, Jan. 20–Mar. 6. Catalogue.

2004
Bremen, Germany, Künstlerhaus Bremen, *Emily Jacir: Woher wir kommen*, Oct. 30–Nov. 28.

Innsbruck, Austria, Kunstraum Innsbruck, *accumulations*, Sept. 4–Oct. 16.

Stockholm, Moderna Museet, *Emily Jacir: Where We Are From*, Sept. 1–Oct. 24.

Ramallah, Palestine, Khalil Sakakini Cultural Center, *Emily Jacir: Where We Come From*, May 8–21.

2003
Arnhem, Netherlands, Museum voor Moderne Kunst Arnhem, *Emily Jacir: Where We Come From*, Dec. 12, 2003–Mar. 14, 2004.

Linz, Austria, OK-Centrum für Gegenwartskunst, *Emily Jacir: BELONGINGS*, Dec. 5, 2003–Feb. 15, 2004. Catalogue.

SELECTED GROUP EXHIBITIONS

2007
Austin, Blanton Museum of Art, University of Texas, *Transactions*, Sept. 11–Nov. 18. Catalogue.

New York, Queens Museum of Art, *Generation 1.5*, June 10–Dec. 2. Catalogue.

Venice, 52nd Venice Biennale, *Think with the Senses, Feel with the Mind: Art in the Present Tense*, June 10–Nov. 21. Catalogue.

New York, Brooklyn Museum, *Global Feminisms*, Mar. 23–July 1. Traveled to Wellesley, Massachusetts, Davis Museum and Cultural Center, Wellesley College, Sept. 19–Dec. 9. Catalogue.

Sienna, Italy, Palazzo delle Papesse Centro Arte Contemporanea, *System Error: war is a force that gives us meaning*, Feb. 3–June 3. Catalogue.

2006
New York, P.S. 1 Contemporary Art Center, *Altered, Stitched, and Gathered*, Dec. 14, 2006–Jan. 28, 2007.

Taipei, Taiwan, 2006 Taipei Biennial, *Dirty Yoga*, Nov. 4, 2006–Feb. 27, 2007. Catalogue.

Istanbul, İstanbul Modern, *Venice-İstanbul*, Oct. 18, 2006–Feb. 2, 2007. Catalogue.

Metz, France, Fonds Régional d'Art Contemporain de Lorraine, *Maintenant, ici, là-bas*, Sept. 16–Nov. 5. Catalogue.

Sydney, 2006 Biennale of Sydney, *Zones of Contact*, June 8–Aug. 27. Catalogue.

New York, Artists Space, *When Artists Say We*, Mar. 8–Apr. 29.

New York, The Museum of Modern Art, *Without Boundary: Seventeen Ways of Looking*, Feb. 26–May 22. Catalogue.

2005
San Francisco, CCA Wattis Institute for Contemporary Arts, *General Ideas: Rethinking Conceptual Art 1987–2005*, Sept. 15–Nov. 13. Catalogue.

Venice, 51st Venice Biennale, *Always a Little Further*, June 12–Nov. 6. Catalogue.

Sharjah, United Arab Emirates, Sharjah International Biennial 7, *Belonging*, Apr. 6–June 6. Catalogue.

2004
Gwangju, Korea, *Gwangju Biennale 2004*, Sept. 10–Nov. 13. Catalogue.

Oxford, England, Modern Art Oxford, *Wherever I Am*, July 20–Sept. 12. Catalogue.

London, Royal College of Art, *This Much is Certain*, Mar. 13–Apr. 4. Catalogue.

New York, Whitney Museum of American Art, *Whitney Biennial 2004*, Mar. 11–June 13. Catalogue.

St. Gallen, Switzerland, Kunstmuseum St. Gallen, *Global World / Private Universe*, Feb. 14–Mar. 31.

2003
Istanbul, 8th International Istanbul Biennial, *Poetic Justice*, Sept. 20–Nov. 16. Catalogue.

2002
Graz, Austria, Grazer Kunstverein, *Routes: Imaging travel and migration*, Oct. 27–Dec. 22. Catalogue.

2000
New York, P.S. 1 Contemporary Art Center, *Greater New York: New Art in New York Now*, Feb. 27–May 14. Catalogue.

JOACHIM KOESTER

BORN 1962 IN COPENHAGEN, DENMARK
LIVES AND WORKS IN COPENHAGEN AND NEW YORK

SELECTED SOLO AND TWO-PERSON EXHIBITIONS

2008
Copenhagen, Galleri Nicolai Wallner, *Joachim Koester: Tarantism + Pit Music*, Jan. 25–Mar. 29.

2007
Brussels, Galerie Jan Mot, *Joachim Koester: Twelve (Former) Real Estate Opportunities*, Nov. 9–Dec. 22.

Stockholm, Moderna Museet, *Min yttre gräns är en oändlig mur av punkter*, Aug. 1–Sept. 16.

2006
Paris, Palais de Tokyo, *Le matin des Magiciens*, Dec. 7, 2006–Jan. 14, 2007.

Barcelona, Center d'Art Santa Monica, *Joachim Koester: Fantasmal*, June 30–Sept. 24.

2005
New York, Greene Naftali Gallery, *Joachim Koester: Morning of the Magicians*, Nov. 21, 2005–Jan. 7, 2006.

Brussels, Galerie Jan Mot, *Joachim Koester: Message from Andrée*, May 5–June 18.

New York, The Kitchen, *Sandra of the Tuliphouse or How to Live in a Free State* (in collaboration with Matthew Buckingham), Apr. 26–June 18.

2002
Nuremberg, Germany, Kunsthalle Nürnberg, *Different Stories, Different Places*, Feb. 28–Apr. 14. Catalogue.

2001
Paris, Centre National de la Photographie, *Joachim Koester*, Mar. 7–May 14.

2000
San Antonio, Artpace, *Joachim Koester*, June 9–July 16.

1998
Milwaukee, Institute of Visual Arts, University of Wisconsin, *Sandra of the Tuliphouse* (in collaboration with Matthew Buckingham). May 8–Aug. 2.

SELECTED GROUP EXHIBITIONS

2007
Auckland, New Zealand, Auckland Art Gallery, *Mystic Truths*, June 30–Oct. 14. Catalogue.

Zurich, Fotomuseum Winterthur, *Forschen und Erfinden: Die Recherche mit Bildern in der zeitgenössischen*, June 2–Aug. 19.

Thessaloniki, Greece, *Heterotopias: First Contemporary Art Biennale of Thessaloniki*, May 21–Sept. 30. Catalogue.

Sharjah, United Arab Emirates, Sharjah International Biennial 8, *Still life: Art, Ecology, and the Politics of Change*, Apr. 4–June 4. Catalogue.

Moscow, *2 Moscow Biennale of Contemporary Art*, Mar. 1–Apr. 1. Catalogue.

2006
Busan, Korea, *Busan Biennale 2006*, Sept. 16–Nov. 25. Catalogue.

Paris, Palais de Tokyo, *Cinq milliards d'années*, Sept. 14, 2006–Jan. 14, 2007.

San Francisco, CCA Wattis Institute for Contemporary Arts, *Prophets of Deceit*, Sept. 12–Nov. 11.

Freiburg, Germany, Kunstverein Freiburg, *UNSICHTBARE WELTEN*, June 14–Aug. 6. Catalogue.

2005
Vilnius, Lithuania, Contemporary Art Center, 9th Baltic Triennial of International Art, *BMW (Black Market Worlds)*, Sept. 23–Nov. 20. Catalogue.

Venice, Danish Pavilion, *51st Venice Biennale*, June 12–Nov. 6. Catalogue.

Aachen, Germany, Neuer Aachener Kunstverein, *Some Trees*, Jan. 16–Mar. 27. Traveled to Dresden, Staatliche Kunstsammlungen, Sept. 23, 2005–Jan. 2, 2006.

2004
Philadelphia, Institute of Contemporary Art, University of Pennsylvania, *The Big Nothing*, May 1–Aug. 1. Catalogue.

2003
Berlin, Kunstwerke, *Territories*, June 1–Sept. 7. Traveled to Rotterdam, Witte de With, Nov. 14, 2003–Jan. 4, 2004; Malmö Konsthall, May 28–Aug. 22, 2004. Catalogue.

2002
Mexico City, Museo Tamayo Arte Contemporáneo, *Todos somos pecadores: Arte nórdico contemporáneo*, Aug. 29–Nov. 17. Traveled to Monterrey, Museo de Arte Contemporáneo, Mar. 27–June 27, 2003. Catalogue.

Chicago, Museum of Contemporary Art, *Out of Place: Contemporary Art and the Architectural Uncanny*, June 8–Aug. 11. Traveled to Gainesville, Samuel P. Harn Museum of Art, University of Florida, Sept. 3–Nov. 24. Catalogue.

2000
New York, P.S. 1 Contemporary Art Center, *Greater New York: New Art in New York Now*, Feb. 27–May 14. Catalogue.

Stockholm, Moderna Museet, *Organising Freedom: nordisk 90-tals konst*, Feb. 12–Apr. 9. Catalogue.

1999
Oslo, Astrup Fearnley Museet for Moderne Kunst, *Pleasureville—Utopian Cities*, Aug. 19–Oct. 10. Catalogue.

Eindhoven, Netherlands, Van Abbemuseum, *Cinéma Cinéma: Contemporary Art and the Cinematic Experience*, Feb. 13–May 24. Catalogue.

1998
Cologne, Kölnischer Kunstverein, *h:min:sec: An exhibition on time*, Oct. 24–Dec. 23. Traveled to Innsbruck, Kunstraum Innsbruck, Oct. 2–Dec. 31, 1999. Catalogue.

Stockholm, Moderna Museet, *I skuggan av ljuset—fotografioch systematic I konst, vetenskapoch och vardagsliv*, Oct. 3–Nov. 15. Catalogue.

Kassel, Germany, Kunsthalle Fridericianum, *Something is Rotten in the State of Denmark*, July 12–Sept. 13. Catalogue.

Paris, Musée d'Art Moderne de la Ville de Paris, *Nuit blanche : scènes nordiques: les années 90*, Feb. 7–May 10. Catalogue.

1997
New York, P.S.1 Contemporary Art Center, New York, *Heaven: Public View, Private View*, Oct. 29, 1997–Feb. 1, 1998.

Johannesburg, South Africa, 2nd Johannesburg Biennale, *Trade Routes: History and Geography*, Oct. 12–Dec. 12. Catalogue.

Kassel, Germany, Documenta X, June 21–Sept. 28. Catalogue.

ROMAN SIGNER

BORN 1938 IN APPENZELL, SWITZERLAND
LIVES AND WORKS IN ST. GALLEN, SWITZERLAND

SELECTED SOLO EXHIBITIONS

2008
Maastricht, Netherlands, Bonnefantenmuseum, *Roman Signer: Strassenbilder*, May 25, 2008–Jan. 18, 2009. Catalogue.

Auckland, New Zealand, St. Paul St. Gallery, Auckland University of Technology School of Art and Design and ARTSPACE, *Roman Signer: Sculpting in Time*, Mar. 14–May 2. Catalogue.

2007
Edinburgh, Scotland, Fruitmarket Gallery, *Roman Signer: Works*, Nov. 2, 2007–Jan. 27, 2008. Catalogue.

Berlin, Hamburger Bahnhof-Museum für Gegenwart, *Roman Signer*, Sept. 30, 2007–Jan. 27, 2008. Traveled to Rochester, Minnesota, Rochester Art Center, May 10–Sept. 14, 2008. Magazine.

2006
Aachen, Germany, Ludwig Forum für Internationale Kunst, *Roman Signer: Kunstpreis Aachen 2006*, Dec. 16, 2006–Feb. 25, 2007.

Paris, Centre Culturel Suisse, *Aller / Retour 3: Roman Signer*, Sept. 10–Nov. 12.

Aarau, Switzerland, Aargauer Kunsthaus, *Roman Signer—REISEFOTOS*, Aug. 19–Nov. 5. Catalogue.

Santiago de Compostela, Spain, Centro Galego de Arte Contemporánea, *ROMAN SIGNER. ESCULTURAS E INSTALACIÓNS*, Jan. 20–Mar. 31. Catalogue.

2005
Linz, Austria, OK-Centrum für Gegenwartskunst, *Roman Signer: WERKE*, June 4–July 24. Catalogue.

2003
St. Gallen, Switzerland, Hauser & Wirth Collection, *Roman Signer: Works*, May 11–Oct. 12. Catalogue.

Tokyo, Shiseido Gallery, *Roman Signer: Recent Works*, Feb. 11–Mar. 30. Catalogue.

2001
London, Camden Arts Centre, *Roman Signer*, Nov. 30, 2001–Feb. 3, 2002. Catalogue.

Pulheim-Stommeln, Germany, Synagoge Stommeln, *Roman Signer. Installation*, Oct. 7–Dec. 2. Catalogue.

Münster, Germany, LWL–Westfälisches Landesmuseum für Kunst und Kulturgeschichte, *Roman Signer: Zeichnungen und Filme*, Sept. 22–Nov. 25. Traveled to Solothurn, Kunstmuseum Solothurn, Mar. 31–June 10. Catalogue.

Kilkenny, Ireland, Butler Gallery, *Roman Signer: Recent and New Work*, Aug. 11–Sept. 30. Catalogue.

Llandudno, Wales, Oriel Mostyn Gallery, *Roman Signer: Works 1971–2000*, Feb. 10–Mar. 17. Catalogue.

2000
Maastricht, Netherlands, Bonnefantenmuseum, *Roman Signer: Works 1971–2000*, Oct. 14, 2000–Jan. 28, 2001. Catalogue.

1999
Vienna, Secession, *Installations*, Oct. 7–Nov. 18. Catalogue.

Venice, Swiss Pavilion, *48th Venice Biennale*, June 13–Nov. 17. Catalogue.

1997
Bloomfield Hills, Michigan, Cranbrook Art Museum, *The Sound of One Bomb Clapping: Sculpture, Actions and Drawings by Roman Signer*, Sept. 13–Oct. 26.

Philadelphia, Goldie Paley Gallery, Moore College of Art & Design, *Roman Signer: Works*, Jan. 24–Mar. 13. Catalogue.

New York, Swiss Institute, *Roman Signer*, Jan. 20–Dec. 23.

1996
Isafjördur, Iceland, Galleri Slunkaríki, *Roman Signer*, Jan. 20–Feb. 11.

1995
Eindhoven, Holland, Het Apollohuis, *Roman Signer: Works*, Mar. 5–Apr. 30.

1993
St. Gallen, Switzerland, Kunstmuseum St. Gallen, *Roman Signer: Skulptur*, Dec. 4, 1993–Feb. 20, 1994. Catalogue.

1992
Thiers, France, Le Creux de l'Enfer–Centre d'art contemporain, *Roman Signer*, Dec. 18, 1992–Feb. 21, 1993. Catalogue.

Thun, Switzerland, Kunstmuseum Thun, *Roman Signer: Arbeiten, Installationen*, Apr. 30–June 14.

Fribourg, Switzerland, FRI-ART Centre d'art contemporain, *VITESSE: 2'000 M/SEC*, Mar. 1–Apr. 5.

1989
Schaffhausen, Switzerland, Museum zu Allerheiligen, *Roman Signer: Skulptur*, Aug. 20–Sept. 24.

1985
Stuttgart, Germany, Künstlerhaus Stuttgart, *Roman Signer: Schnelle Veränderungen*, June 25–July 13. Catalogue.

1983
Winterthur, Switzerland, Kunstmuseum Winterthur, *Roman Signer: Zeichnungen und Aktionsdokumentationen*, Oct. 22–Nov. 27.

1982
Utrecht, Netherlands, Museum Hedendaagse Kunst, *Roman Signer*, Apr. 30–June 6. Catalogue.

1981
Zürich, Kunsthaus Zürich, *Roman Signer: Filminstallation*, June 13–July 19. Catalogue.

SELECTED GROUP EXHIBITIONS

2006
Paris, Palais de Tokyo, *UNE SECONDE UNE ANNÉE*, Sept. 14–Dec. 31.

1999
Pittsburgh, Carnegie Museum of Art, *Carnegie International 1999 / 2000*, Nov. 6, 1999–Mar. 26, 2000. Catalogue.

Liverpool, England, Liverpool Biennial of Contemporary Art, *TRACE*, Sept. 24–Nov. 7. Catalogue.

1998
Minneapolis, Walker Art Center, *Unfinished History*, Oct. 18, 1998–Jan. 10, 1999. Catalogue.

1997
Münster, Germany, Westfälisches Landesmuseum für Kunst und Kulturgeschichte, *Skulptur. Projekte in Münster 1997*, June 22–Sept. 28. Catalogue.

1995
Amsterdam, De Appel, *shift*, Apr. 22–June 18. Catalogue.

1991
Chicago, The Renaissance Society at The University of Chicago, *A Swiss Dialectic*, May 8–June 23.

1987
Kassel, Germany, Documenta 8, June 21–Sept. 20. Catalogue.

CONTRIBUTORS

T.J. DEMOS is a critic and lecturer in the Department of Art History, University College London. The author of *The Exiles of Marcel Duchamp* (MIT Press, 2007), his essays on modern and contemporary art have appeared in international journals such as *Artforum*, *Grey Room*, *October*, and *Texte zur Kunst*. Demos is currently at work on a new book, provisionally titled *Migrations: Contemporary Art and Globalization*.

HELICOPTER is an award-winning creative services consultancy founded by partners Ethan Trask and Joshua Liberson. Helicopter's diverse range of clients include André Balazs Properties, Capitol Records, Condé Nast Publications, Hachette Filipacchi Media, Nyehaus Gallery, Rizzoli Books, Time, Inc. and The Washington Post Company. Helicopter is based in New York and at www.hellochopper.com.

LIZA JOHNSON is an artist and filmmaker. Her work has been exhibited internationally in museums, galleries, and film festivals, including the Wexner Center for the Arts, the Walker Art Center, and the Centre Pompidou, as well as the New York, Berlin, and Rotterdam Film Festivals, among many others. She has been a fellow of the DAAD Berliner Künstlerprogramm and the Sundance Institute, and has published a number of articles and interviews about art and film. Johnson is Associate Professor of Art at Williams College.

SHANNA KETCHUM-HEAP OF BIRDS is a noted critic and art historian of contemporary Native American art. Her articles have appeared in major publications across the globe including *Third Text* and *Estrago*, and she has written for institutions including the Smithsonian National Museum of the American Indian, and the Massachussetts College of Art. Ketchum-Heap of Birds lectures, both nationally and internationally, about contemporary issues in Native art and teaches at the University of Oklahoma in Norman.

LARS BANG LARSEN is writing his Ph.D. at the University of Copenhagen on the global dissemination of psychedelic art and culture of the 1960s. He works as a freelance curator and critic who contributes regularly to *Artforum*, *Frieze*, and *Afterall*.

GERHARD MACK currently works as editor for art and architecture for the Sunday edition of the *Neue Zürcher Zeitung*, Zurich. He has published on numerous artists and architects. Among his recent books are *Art Museums into the 21st Century* and the monographs on Hans Josephsohn and Rémy Zaugg. He is editor of the complete works of Herzog & de Meuron, of which volume four will be published this year.

CAPTIONS & PHOTO CREDITS

PHOTO CREDITS

Page 3 [above]
Courtesy Marian Goodman
Gallery, New York and Paris

[below]
Matthias Herrmann

Page 4 [above]
Pierre Huyghe, courtesy
Marian Goodman Gallery,
New York and Paris

[below]
Eli Ping Weinberg, courtesy
the artist and Max Protetch
Gallery, New York

Page 5 [above]
Matthias Langer, courtesy
Kunstmuseum Wolfsburg

[below]
Neville Wakefield,
courtesy the artist

Page 9
Christoph Büchel

Pages 10 [above], 73–83:
Courtesy Joachim Koester

Pages 10 [below], 32 [below],
36 [above and below],
37 [below]
Patty Chang

Page 11 [above]
Thomas R. Dubrock,
© Sam Durant

[below]
Giovanni Pancino

Page 12
Marek Rogowiec

Pages 15–27
Mario Testino

Page 32 [above]
Neraldo de la Paz

Page 34
Patty Chang and David Kelley

Page 35
Tim McConville

Page 37 [above]
Courtesy Frac Ile-de-
France/Le Plateau, Paris

Pages 38–41
Patty Chang and David Kelley

Pages 46–48
Ellen Wilson, © Sam Durant

Pages 49 [above],
55 [below, right]
Sam Durant

Pages 49 [below],
55 [below, upper left]
Chloé Zaug

Pages 50–52
John Paul Doguin
© Sam Durant

Page 55
[below, lower left]
Clint Baclawski

Pages 59–60, 64–69
Courtesy Emily Jacir
and Alexander and
Bonin, New York

Pages 61, 90
Stefan Rohner

Pages 62, 63
Bill Orcutt

Pages 88, 95, 97
Roman Signer

Page 89 [above and below]
Video stills by
Aleksandra Signer

Page 91
Super-8 film stills by
Peter Liechti

Page 92
Aleksandra Signer

Page 93
Rudolf Steiner

Page 84:
Video stills by Aufdi
Aufdermauer and
Francis Gomila

Page 96
Michael Bodenmann

ARTISTS' PAGES

PATTY CHANG

Page 35
In Love, 2001
Two-channel video
installation with color
and sound, 3 min. 28 sec.
Installation view, Chinese
Arts Centre, Manchester,
England, 2005

Page 36 [above]
Chez Les Grecs, 2004
Video with color and
sound, 25 min.

[below]
Shaved (At a Loss), 1998
Video with color and
sound, 5 min. 19 sec.

Page 37 [above]
Stage Fright #2, 2003
Performance photograph

[below]
Sorority Stage Fright, 2004
Digital C-print, 6.2 x 101.6 cm

Page 38
Patty Chang and David Kelley,
*Shangri-La (Mirror
Mountain-Bricks)*, 2005
C-print, 50.8 x 61 cm

Page 39
Patty Chang and David Kelley,
*Shangri-La (Styrofoam
Mountain-Sky)*, 2005
C-print, 50.8 x 61 cm

Page 40
Patty Chang and David Kelley,
Linyi and Tiger, 2007
Digital C-print, 101.6 x 127 cm

Page 41 [above]
Patty Chang and David Kelley,
Flotsam Jetsam, 2007
Video with color and
sound, 30 min.

[below]
Patty Chang and David Kelley,
*Hua Building Shot and
Reverse*, 2007
Diptych: 2 digital C-prints,
101.6 x 127 cm each

SAM DURANT

Page 49 [above]
National Day of Mourning
plaque, Plymouth,
Massachusetts

[below]
Metacomet (King Philip)
plaque, Plymouth,
Massachusetts

Pages 50–51
*Subject/Position/Object/
Placement (Pilgrim
Monuments: Massasoit,
Metacomet, and
Plymouth Rock)*, 2006
Fiberglass, wood, steel,
polyurethane, synthetic
hair, fur, synthetic fur,
leather, acrylic, 182.9
x 350.5 x 152.4 cm

Installation view,
Massachusetts College
of Art and Design,
Stephen D. Paine Gallery,
Boston, 2006

Pages 52–54
*Pilgrims and Indians,
Planting and Reaping,
Learning and
Teaching*, 2006
Wax museum figures
and props, motorized
rotating platform
274.3 cm high, 487.7 cm in
diameter. Installation view,
Massachusetts College of
Art and Design, Stephen D.
Paine Gallery, Boston, 2006

Page 55 [above]
Vintage Postcards from
Plymouth National Wax
Museum (front & back)

[below, clockwise
from top left]
Metacomet (King Philip)
plaque, Plymouth,
Massachusetts

Cyrus E. Dallin,
Massasoit, Plymouth,
Massachusetts, 1921
Bronze, 274.3 cm high,
base: approx. 137.2 x
152.4 x 137.2 cm
Plymouth Rock, Plymouth,
Massachusetts

EMILY JACIR

Page 63
Inbox, 2004–05 (detail)
Oil on wood in 45 parts,
28 x 21.5 cm each
Courtesy Alexander
and Bonin, New York
Originally commissioned
by Kunstraum, Innsbruck

Pages 64–65
linz diary, 2003
Set of 26 color photographs,
20.5 x 22.5 cm each
Courtesy the artist
and Alexander and
Bonin, New York

Page 68
Material for a film,
2005–ongoing (detail)
Multimedia installation
with 3 sound pieces, video,
texts, photos, and archival
material, dimensions
vary with installation
Courtesy the artist
and Alexander and
Bonin, New York.
This work was developed
with the support of
the Venice Biennale

Page 69
*Material for a film
(performance)*,
2005–06 (details)
Installation and
performance, 1000 blank
books shot by the artist
with a 22-caliber gun, mixed
media, 67 color photographs,
and wood, dimensions
vary with installation
Courtesy the artist
and Alexander and
Bonin, New York
Originally commissioned
by *Zones of Contact:
2006 Biennial of Sydney*

JOACHIM KOESTER

Pages 77–79
Tarantism, 2007
16 mm black-and-white
film, 6 min. 31 sec.

Page 81
Message from Andrée,
2005 (detail)
16 mm film installation with
16 mm black-and-white
film, 3 minutes, 24 seconds,
looped; 2 inkjet posters,
136 x 99 cm each; and text

Pages 82–83
*Morning of the
Magicians*, 2006
16 mm black-and-white
film, 5 minutes

ROMAN SIGNER

Page 91
*Falling through the Ice
(Einbruch in Eis)*, 1986

Page 22
Shirt (Hemd), 2005

Page 93
*Piaggio on Ski Jump
(Piaggio auf Schanze)*, 2003
Chocholow, Poland

Page 94
*Bucket with Camera
(Eimer mit Kamera)*, 2002
Bewick Court,
Newcastle, England

Page 95
*Narrow Pass
(Engpass)*, 2000
Hamburg

Page 96
Bicycle (Fahrrad), 2005

Page 97
*Table, Iceland
(Tisch, Island)*, 1994

INTERNATIONAL DIRECTOR'S COUNCIL

PRESIDENT

Tiqui Atencio Demirdjian

EXECUTIVE COMMITTEE

Christina Baker, Janna Bullock, Rita Rovelli Caltagirone,
Dimitris Daskalopoulos, Harry David, Caryl Englander,
Shirley Fiterman, Laurence Graff, Nicki Harris,
Dakis Joannou, Rachel Lehmann, Linda Macklowe,
Peter Norton, Katharina Otto-Bernstein, Tonino Perna,
Inga Rubenstein, Simonetta Seragnoli, Cathie Shriro,
Ginny Williams, Elliot Wolk

GENERAL MEMBERSHIP

Ann Ames, Roberta Amon, Phyllis Asch, Karen Berger,
Michele Beyer, Giulia Ghirardi Borghese, Denise LeFrak
Calicchio, Violetta Caprotti, Payal and Rajiv Chaudhri,
Gérard Cohen, Milton Dresner, Maxine Eisenberg,
Leonard Feinstein, Linda Fischbach, Judie Ganek,
Smadar Goldstein, Beatrice Habermann, Dana Hammond
Stubgen, Susan Hancock, William Haseltine,
Carole Shorenstein Hays, Jeffrey Hays, Janet Hershaft,
Barbara Horowitz, Fern Hurst, Miryam Knutson, Dorothy Kohl,
Nancy Lane, Lin Lougheed, Phyllis Mack, Sondra Mack,
Cargill MacMillan, Donna MacMillan, Suzana Maus,
Isabella del Frate Rayburn, Lyn Ross, Rachel Rudin,
Lilly Scarpetta, Jane Scheinfeld, Carolyn Wade, Victoria Wyman

HONORARY MEMBERS

Miriam and Sheldon Adelson, Ulla Dreyfus-Best,
Frank Gehry, Audrey and Martin Gruss, Gheri Sackler

THE SOLOMON R. GUGGENHEIM FOUNDATION

HONORARY TRUSTEES IN PERPETUITY
Solomon R. Guggenheim
Justin K. Thannhauser
Peggy Guggenheim

HONORARY CHAIRMAN
Peter Lawson-Johnston

CHAIRMAN
William L. Mack

PRESIDENT
Jennifer Blei Stockman

VICE-PRESIDENTS
Frederick B. Henry
Wendy L-J. McNeil
Stephen C. Swid
Mark R. Walter

DIRECTOR
Thomas Krens

TREASURER
Edward H. Meyer

SECRETARY
Edward F. Rover

TRUSTEES EX OFFICIO
Tiqui Atencio Demirdjian
PRESIDENT, INTERNATIONAL
DIRECTORS COUNCIL

Robert J. Tomei
CHAIRMAN, EXECUTIVE
COMMITTEE,
PEGGY GUGGENHEIM COLLECTION
ADVISORY BOARD

DIRECTOR EMERITUS
Thomas M. Messer

TRUSTEES
Jon Imanol Azua
Robert Baker
Peter M. Brant
Janna Bullock
John Calicchio
Mary Sharp Cronson
David Ganek
Frederick B. Henry
Thomas Krens
Peter Lawson-Johnston
Peter Lawson-Johnston II
Howard W. Lutnick
William L. Mack
Linda Macklowe
Wendy L-J. McNeil
Edward H. Meyer
Amy Phelan
Vladimir O. Potanin
Stephen M. Ross
Mortimer D. A. Sackler
Denise Saul
James B. Sherwood
Raja W. Sidawi
Seymour Slive
Jennifer Blei Stockman
Stephen C. Swid
John S. Wadsworth, Jr.
Mark R. Walter
John Wilmerding

709.
07

R74215

Published following the selection
of the finalists for The Hugo Boss Prize 2008.

THE HUGO BOSS PRIZE 2008
© 2008 The Solomon R. Guggenheim Foundation,
New York. All rights reserved.

ISBN 978-0-89207-373-3

GUGGENHEIM MUSEUM PUBLICATIONS
1071 Fifth Avenue
New York, New York 10128
www.guggenheim.org

Distributed in North America by
D.A.P./Distributed Art Publishers
155 Sixth Avenue, 2nd floor
New York, NY 10013

Design: Helicopter L.L.C.
Production: Minjee Cho
Editorial: Catherine Bindman, Jean Dykstra,
Stephen Hoban, Helena Winston
Translation: Russell Stockman

Printed in Italy by Graphicom